IMAGES
of America

DEERFIELD

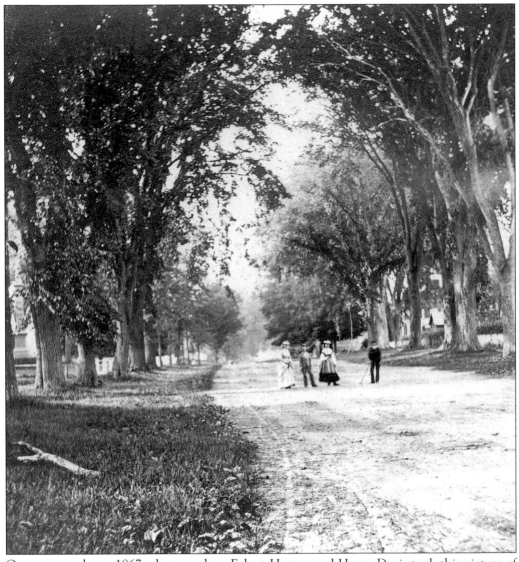

One summer day *c.* 1867, photographers Egbert Horton and Henry Davis took this picture of four children standing on the Street in Old Deerfield. Frances and Mary Allen also took posed photographs of young people. Note the tall elm trees. (Courtesy Peter S. Miller.)

IMAGES
of America

DEERFIELD

Peter S. Miller and Kyle J. Scott

ARCADIA
PUBLISHING

Published by Arcadia Publishing
Charleston SC, Chicago IL, Portsmouth NH, San Francisco CA

Printed in the United States of America

Library of Congress Catalog Card Number: 2002103220

For all general information contact Arcadia Publishing at:
Telephone 843-853-2070
Fax 843-853-0044
E-mail sales@arcadiapublishing.com
For customer service and orders:
Toll-Free 1-888-313-2665

Visit us on the Internet at www.arcadiapublishing.com

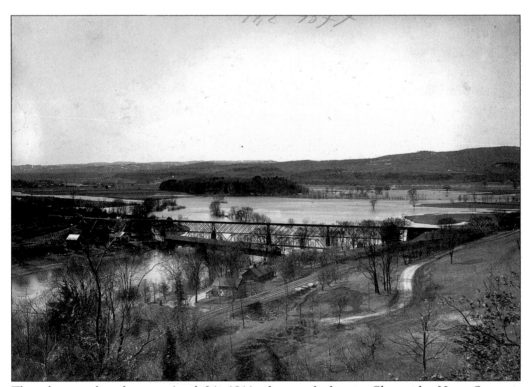

This photograph, taken on April 24, 1911, shows a freshet in Cheapside. Hope Street is winding down the hill to Cheapside Street. The Cheapside Covered Bridge, the trolley bridge, and the railroad bridge are in the center. Until 1896, both sides of the Deerfield River were a part of Deerfield. (Courtesy Peter S. Miller.)

CONTENTS

ACKNOWLEDGMENTS

The authors would like to thank Richard Arms, Mary Marsh, John Kruk, Gerald Fortier, and Betty Hollingsworth for offering their vast collections of Deerfield photographs for this project. Special thanks go to Betty Hollingsworth for her help with the captions on South Deerfield photographs. Thanks go to Penny Leveritt, Bill Flynt, and Joseph Peter Spang for their efforts. Many thanks go to the Historic Society of Greenfield for the use of its photographs and meeting room, where this book was laid out. Thanks also are due the South Deerfield Police Department, the South Deerfield Fire Department, the Bement School, Eaglebrook School, Richard Kittredge, Richardson's Candy Kitchen, the Pekarski Sausage Company, Al Dray, Edna Stahelek, Richard and Nansi Smiaroski, Leonard Galisa, Irving Scott, Donald Y. Bowman, Helen Petrovich, the Recorder, and anyone else who helped in this project. Many of the images came from the personal collection of Peter S. Miller and from his collection of Ned Lamb photographs.

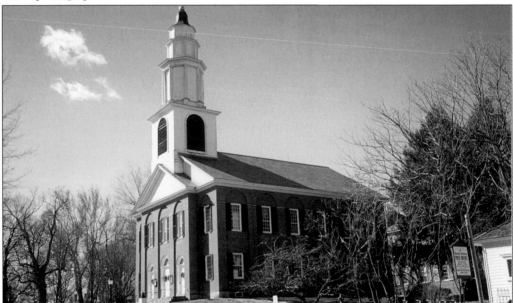

The Brick Church of Deerfield is one of the main landmarks in Old Deerfield. The roots of this church and the town are the same, both going back to the mid-17th century. Of course, Native American roots go even deeper. (Photographer Kyle J. Scott.)

INTRODUCTION

Long before the Europeans came to the New World and the Connecticut River Valley, Native Americans had lived here for thousands of years. They were both drawn here for the deep fertile soil, the Deerfield and Connecticut Rivers, and the plentiful game. Deerfield was founded upon an area of previous settlement of the Pocumtucks. Until the times of the Europeans, they flourished. The diseases of the Europeans and the *c.* 1664 attack on their village by the Mohawks finished the Pocumtucks as a tribe. The Europeans and the Native Americans had completely differing ideas of ownership of land. Capt. John Pynchon of Springfield purchased some of the Pocumtucks' land, and ownership was passed to the proprietors of the town of Deerfield.

Deerfield was first laid out in the Old Deerfield section of the town. Everyone had a house lot on the mile-long street and a strip of land going back to the nearby mountain or the Deerfield River. During the early years, the settlement was plagued by King Phillip's War and the various other wars with the French and Native Americans. The town was abandoned twice. In 1675, as a group of settlers was leaving the area with gathered crops, some Native Americans ambushed them. This ambush, at Bloody Brook, killed more Europeans at one time than any other period during King Phillip's War. The next big tragic event was the attack on the village during the early-morning hours of February 29, 1704. The French and their Native American allies attacked the north end of the street and the fort. Many people, including Rev. John Williams, were marched to Quebec. About two thirds of the surviving captives returned to Deerfield.

Farmers made their money by raising cattle and by growing corn, tobacco, and other crops. Before the advent of the railroads, the Connecticut River was turned into a highway for boats. Cheapside was a river port. The coming of the railroads ended the value of Cheapside and drove down the value of the agriculture in Deerfield. The East Deerfield Freight Yard came later. The yard provided hundreds of jobs for the local area.

Deerfield survived the Revolutionary War without ridding itself of those who favored the crown. This feeling carried over to loyalist Rev. Jonathan Ashley. During the Civil War, the town did send its minister, Reverend Moors, to war. After the war, agriculture declined. During the late 19th century, the arts and crafts came into vogue. Many of the women of Old Deerfield became involved in this endeavor. Included in this era were Frances and Mary Allen, photographers who were well known throughout the United States. South Deerfield got started later in the 18th century. The advent of the railroad helped develop that section of town. With the growing of tobacco and other crops, agriculture became important to that part of town. Today, it is the industrial section of town, featuring the pickle factory, the fertilizer plant, the plastic plant, Bete Publishing, and the Yankee Candle Company. Yankee Candle is the second-biggest tourist attraction in Massachusetts.

George Sheldon was a great Deerfield historian and gatherer of Deerfield items. He helped found the Pocumtuck Valley Memorial Association and Memorial Hall Museum. Thanks to the efforts of Tim Newman, Susanne Flynt, and many others, that organization is flourishing. Old Deerfield today is the product of two couples: Frank and Helen Boyden and Henry N. and Helen Grier Flynt. The Boydens came first, and they worked as a team. Frank Boyden came to save Deerfield Academy. Thanks to his spirit, drive, community spirit, and fund-raising abilities, he more than saved the school. He also got the Flynts involved with Old Deerfield. Soon, the Flynts were purchasing houses on Main Street in Old Deerfield and were doing restoration work on them. Some of these houses ended up with Deerfield Academy, the Bement School, and the First Church. The rest went to what eventually became Historic Deerfield. Aside from being interested in houses, this couple was also interested in collecting furniture, textiles, silver, and ceramics. William E. Gass Jr. of Deerfield was the designer and contractor for most of Historic Deerfield's old buildings. Much of his work was done in the Colonial Revival manner.

Deerfield occupies some of the most picturesque land in the world. It is heaven for the photographer, and there have been many of them here. Many of the historic buildings in Old Deerfield have been saved. The old section of Deerfield retains its original flavor. The whole town of Deerfield is awaiting your visit both in person and in this book.

One

OLD DEERFIELD

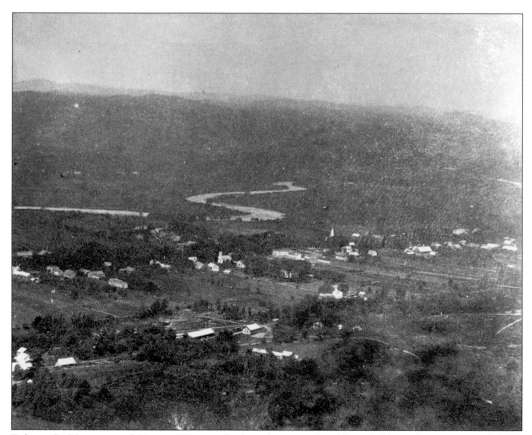

Egbert C. Horton and Henry Wise took this photograph of Deerfield in the summer of 1870 from Pocumtuck Mountain. Visible are houses along the street, the Deerfield River, and fields that extend to the mountain. (Courtesy Peter S. Miller.)

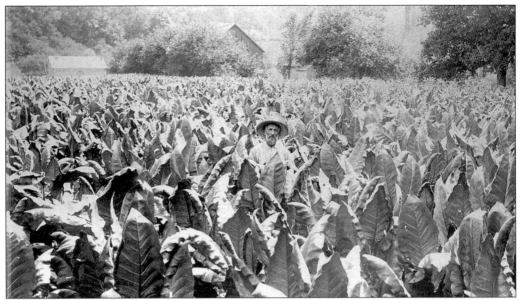

Richard Catlin Arms (1818–1908) stands in his tobacco field behind his house, located at the southern end of the Street in Old Deerfield. Tobacco was once a big cash crop in the Pioneer Valley. At the top left is the New York, New Haven, and Hartford Railroad freight house. In the center is Arms's tobacco barn. (Courtesy Richard Arms and Mary Marsh.)

This c. 1750 house (originally a story and a half) had its front part constructed in 1809. In 1988, the house was updated. This house has been in the Arms family since 1860, when George and Richard C. Arms purchased it. Richard P. Arms, son of Richard C. Arms, built the nearby gas station. (Courtesy Richard Arms and Mary Marsh; photographer Masha Arms.)

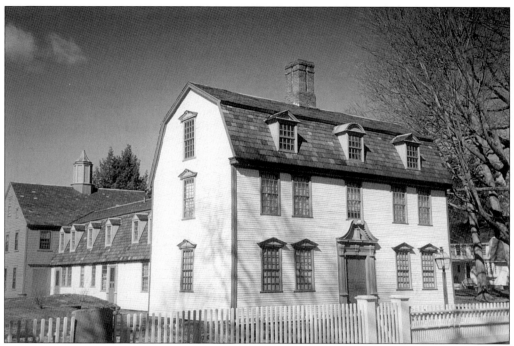

The Dwight House is one of four buildings that were taken apart and rebuilt in Deerfield. This c. 1727 house was first built in Springfield and was later owned by the Dwight family. The Dwights had the Connecticut River Valley doorway and the gambrel roof put on the house. (Photographer Kyle J. Scott.)

This view shows the Childs-Champney House. James Wells Champney was a well-known painter and photographer in New York City and in Deerfield. The Keith family owned this house from 1913 to 1984. (Courtesy Richard Arms and Mary Marsh.)

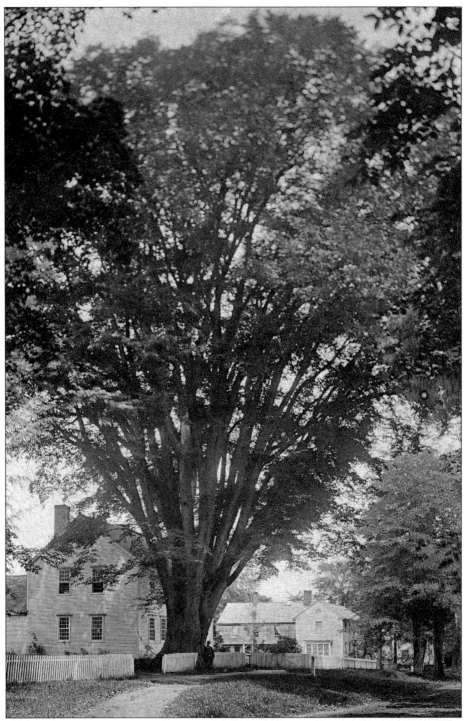

This early-1880s photograph of the Childs-Champney House shows what was then Deerfield's tallest elm tree. In the background is the 1830 Elisha Wells House. The tree was cut down in the winter of 1885. The following year, James Wells Champney moved his house back away from the street. (Courtesy Richard Arms and Mary Marsh.)

This view looks south from the Munn House toward the *c.* 1798 Hezekiah Wright House. (Courtesy Peter S. Miller.)

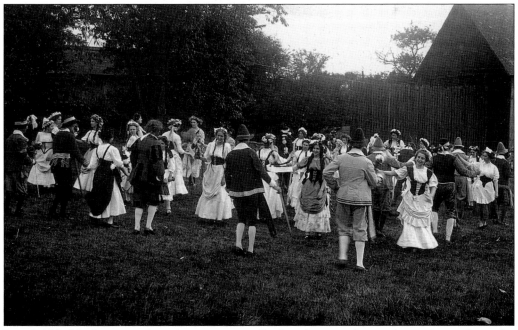

Deerfield held a large number of reenactments. In this photograph, people are shown doing the Virginia reel.

This *c.* 1890 photograph looks north past the Hezekiah Wright House to the Munn House. The view shows an unpaved street, with its tall elms that provided shade.

(Courtesy Richard Arms and Mary Marsh.)

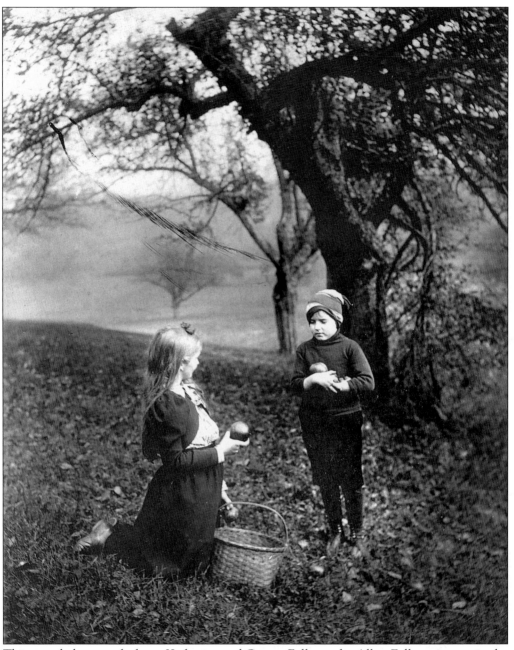

This staged photograph shows Katharine and George Fuller at the Allen-Fuller property, in the Bars, a section of Old Deerfield. (Courtesy Richard Arms and Mary Marsh.)

The *c.* 1755 Jonathan Hoyt House was built in the Cheapside section of Deerfield. At one time, it was known as the White Horse Inn and the farm home of the famous agriculturalist Rev. Henry Colman. The house once stood in Greenfield behind the cement wall at the entrance to Briar Way. (Courtesy Richard Arms and Mary Marsh.)

John Radovich approached Peter Spang and Henry Flynt about saving his parents' home. In 1965–1966, Bill Gass removed the building and reconstructed it in a Colonial Revival style. The original rear wing was not saved. The front doorway is a copy. The building is now the parish house for the Brick Church. (Photographer Peter S. Miller.)

Taken on October 16, 1888, this photograph looks west toward the village from the site of the former Boston and Maine Railroad station. At the center is the roof of the New York, New Haven, and Hartford station. To its right is a telltale. The steeple of the Orthodox

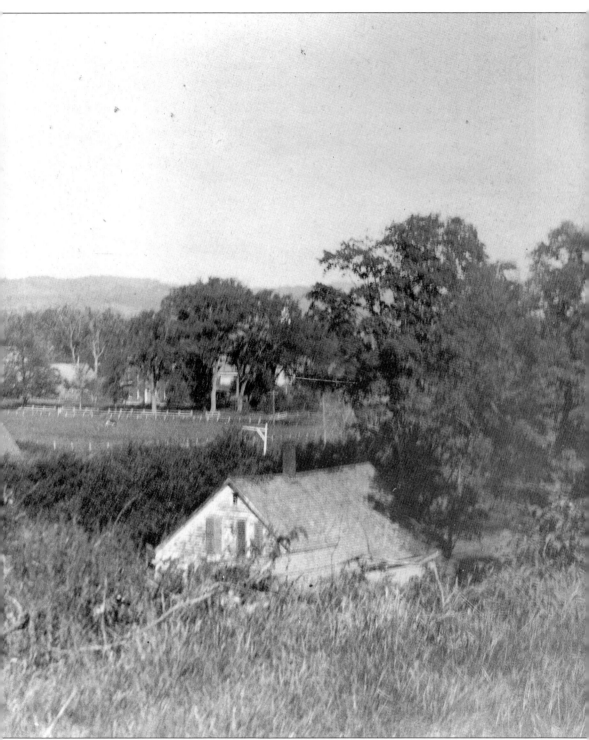

Congregational Church can be seen in the background. (Courtesy Richard Arms and Mary Marsh; photographer A.W. Wilkinson.)

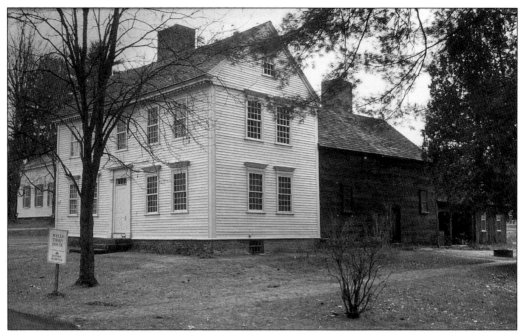

Ebenezer Wells constructed the ell of the Wells Thorn House between 1720 and 1730. The front part of the house was built sometime before he died in 1758. Research indicates that the front part of the house was originally painted blue. The main part of the house is now painted a light blue. (Photographer Peter S. Miller.)

This 1868 view shows children in the street in front of the Frary House. (Courtesy Peter S. Miller; photographers Egbert Horton and Henry Wise.)

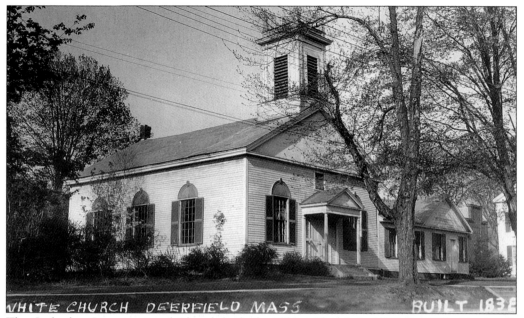

WHITE CHURCH DEERFIELD MASS BUILT 1838

The Orthodox Congregational Church built the White Church in 1838. In 1835, this church group split off from membership in the Brick Church. In 1931, the two churches resolved their differences. In 1957, the forerunner of Historic Deerfield purchased the structure. (Courtesy Gerald Fortier; photographer Ned Lamb.)

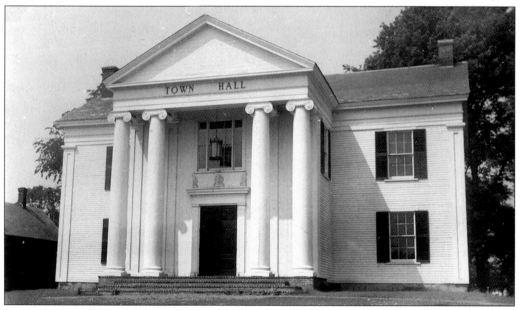

The old town hall for Deerfield was constructed in 1842. In 1925, the building was redone under the direction of Bill Gass to include a front portico. Until 1955, the town meetings were held here and, until c. 1995, the Dickinson Library was housed on the main floor. (Courtesy Gerald Fortier; photographer Ned Lamb.)

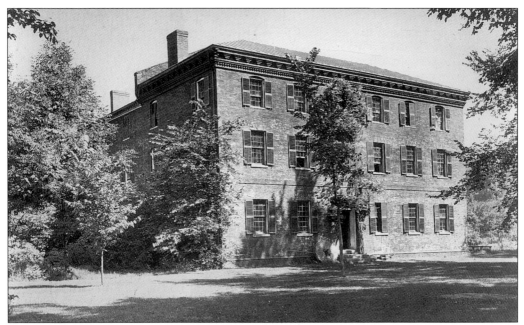

The first home of Deerfield Academy was designed by Asher Benjamin and was constructed c. 1798 by Benjamin and Calvin Hale. Later, a third floor and rear section were added. In 1877, the academy sold the building to the Pocumtuck Valley Memorial Association, and it became a fine local museum. In 1916, an eastern wing was added. (Courtesy Peter S. Miller.)

This c. 1910 photograph shows the Nims House. This is the third Nims house on this property. The 1710 house may have been added to the c. 1744 house (owned by John Nims) as an ell. This ell was greatly altered c. 1808. In 1936, some Nims descendants purchased it and, in 1938, gave it to Deerfield Academy. (Courtesy Peter S. Miller.)

In the background of this *c.* 1868 photograph is the joined Frary House and *c.* 1795 Barnard Tavern. The left section, the Frary House, may contain parts of an original *c.* 1719 structure that was greatly redone in 1765 by Salah Barnard. In 1797, Deerfield Academy was founded in the upstairs ballroom. (Courtesy Richard Arms and Mary Marsh.)

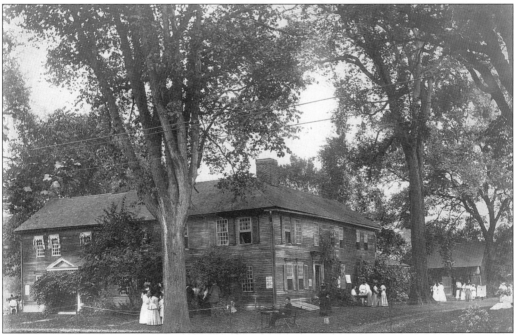

This event, identified as "Miss Coleman's Fair," was held at the Frary House and Barnard Tavern. From 1796 to 1860, both buildings were used as separate structures. In 1890, C. Alice Baker rescued this fine old building from destruction. It was left to the Pocumtuck Valley Memorial Association, which sold it in 1969 to Historic Deerfield. (Courtesy Richard Arms and Mary Marsh.)

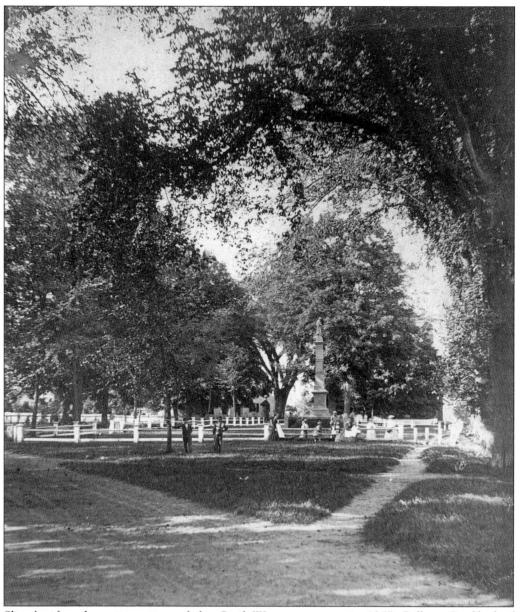

Shortly after the construction of the Civil War monument in 1867, Pelham Bradford of Greenfield came to Deerfield and took this photograph of the common. (Courtesy Peter S. Miller; stereo view by Benjamin J. Popkins.)

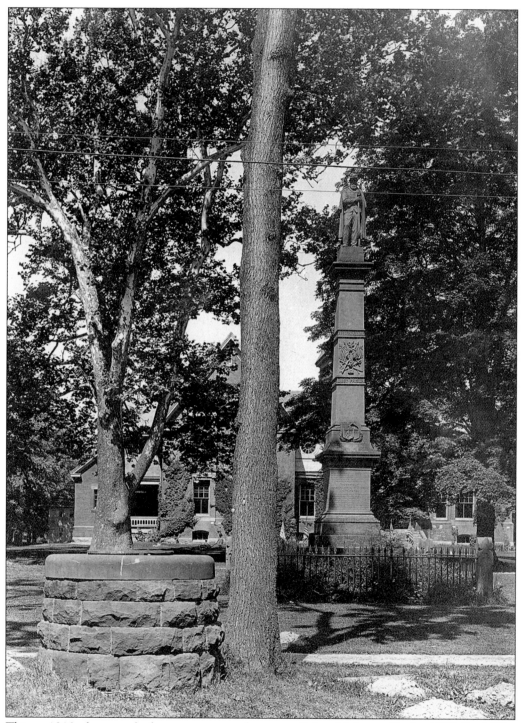

This *c.* 1910 photograph shows a more modern top of the old fort well, the 1867 Civil War monument, and the Dickinson High School building, which stood there between 1877 and 1930. The monument not only commemorates the Civil War but also honors the site of the old fort that once stood around the town common. (Courtesy Peter S. Miller.)

This *c.* 1910 pastoral scene was taken at the very end of the present Old Albany Road. The spire of the Brick Church is in the background, and the ancient burial yard is to the far right. Deerfield Academy now occupies most of this view with buildings and a baseball field. (Courtesy Richard Arms and Mary Marsh.)

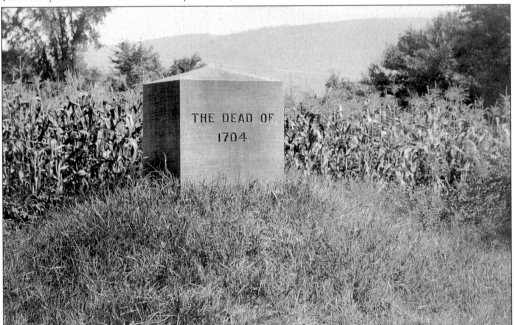

This monument, erected by C. Alice Baker, commemorates the dead of the famous attack on Deerfield on February 29, 1703/4. In the very early hours of that day, the French and their Native American allies attacked the northern part of the street and the fort. About 48 people were killed and were buried on this site in a mass grave. (Courtesy Peter S. Miller.)

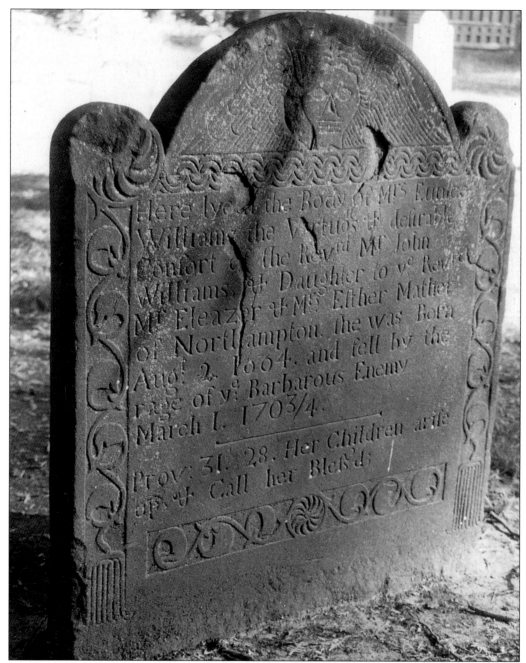

This gravestone reads, "Here lyeth The Body of Mrs. Eunice / Williams the Vertuous the desirable / Consort of the Reved Mr. John / Williams & Daughter to ye Reved / Mr. Ebenezer & Mrs. Esther Mather / of Northampton. She was born / Aug. 2, 1684. And fell by / the rage of ye Barbarous Enemy / March 1, 1703/4. / Prov: 31. 28. Her Children arise / up Call her Bless'd." Previous to the attack, Eunice Williams had given birth. On the next day's march to Canada, near the present covered bridge in Greenfield, she fell into the cold water of the Green River. Thinking that she would not survive, a Native American killed her. (Photographer Peter S. Miller.)

The *c.* 1778 Justin Hitchcock House is located on Old Albany Road. Later, it was the home of Edward Hitchcock, a preceptor of Deerfield Academy and later president of Amherst College. Hitchcock was also a well-known geologist. (Courtesy Gerald Fortier.)

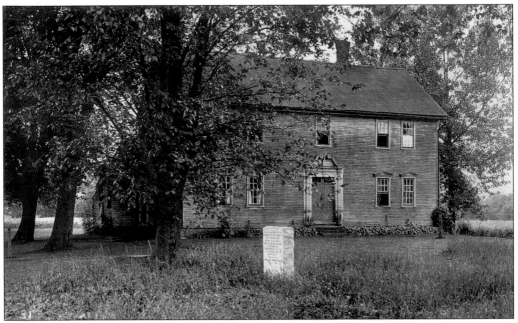

This house, built in 1760 by Elijah Williams (son of Rev. John Williams), was originally located farther east, in front of the house owned by his father. Thanks to George Sheldon, the house was saved *c.* 1877 and moved back to its present site. In 1916, Deerfield Academy turned the house into a dormitory. (Courtesy Peter S. Miller.)

This 1760 Connecticut River Valley doorway graces the entrance to the Elijah Williams House on Old Albany Road. This doorway is the symbol for the 200-year-old Deerfield Academy. In 2001, this doorway was removed by the academy and put into storage. A reproduction doorway replaced it. (Courtesy Peter S. Miller.)

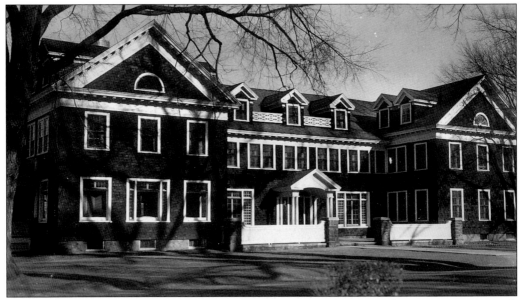

Boyden Hall (or the Old Dorm) was constructed in 1920 and, 38 years later, was torn down. It was located just west of the Elijah Williams House. (Courtesy Gerald Fortier.)

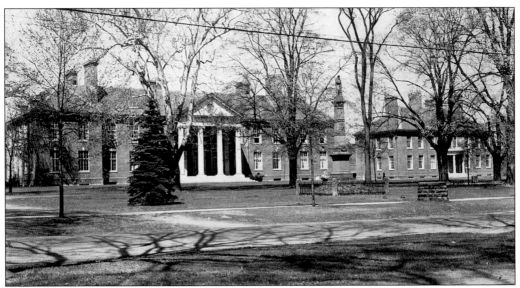

The Deerfield Academy administration building (built in 1931) and the former science building (built in 1933) are across the common. The Dickinson High School building previously occupied this site. (Courtesy Peter S. Miller.)

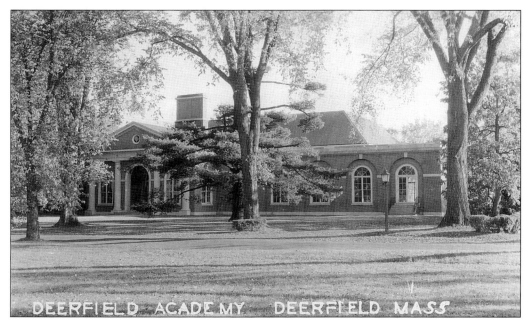

This is the 1932 Deerfield Academy gymnasium. (Courtesy Peter S. Miller.)

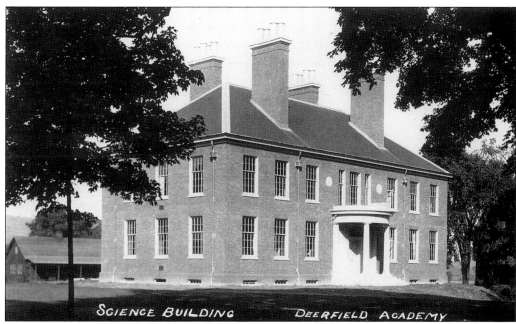

The 1933 science building occupied the former site of the Samuel Wells House. The latter building was moved in 1953 to another site and was used until 1989 as a dormitory. (Courtesy John Kruk.)

David Sexton Jr. built the *c.* 1783 Little Brown House on Old Albany Road. This photograph shows the building during its period as a painting studio for Arthur Negus Fuller. (Courtesy Peter S. Miller.)

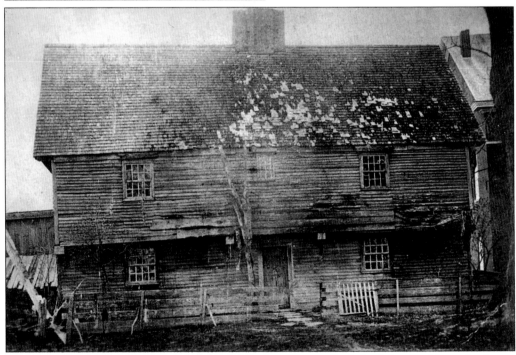

This *c.* 1847 image shows the original 1699 Indian House. Built by John Sheldon, the house survived the 1704 attack on Deerfield. The Brick Church is next door. Despite efforts to try to save the house, it was torn down in 1848. (Courtesy Peter S. Miller.)

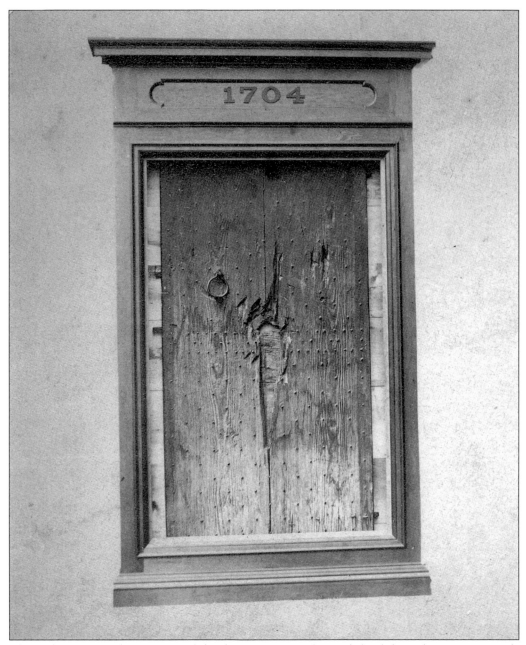

The Indian House door is one of the few remaining objects left of the February 29, 1703/4 attack on Deerfield. Initially, the enemy could not break into the house. A Native American cut a hole into the door and shot a woman who was sitting in a chair. The door is currently in Memorial Hall Museum and is displayed differently. (Courtesy Peter S. Miller.)

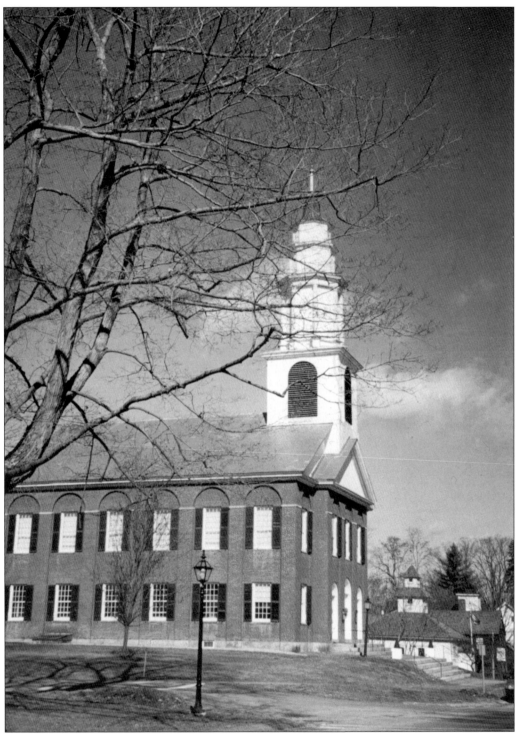

The Brick Church was the fifth church to be built in Deerfield. It was built and designed in 1824 by Winthrop Clapp of Montague. The minister at this time was Rev. Samuel Willard. The official name of the church is the First Church of Deerfield. (Photographer Kyle J. Scott.)

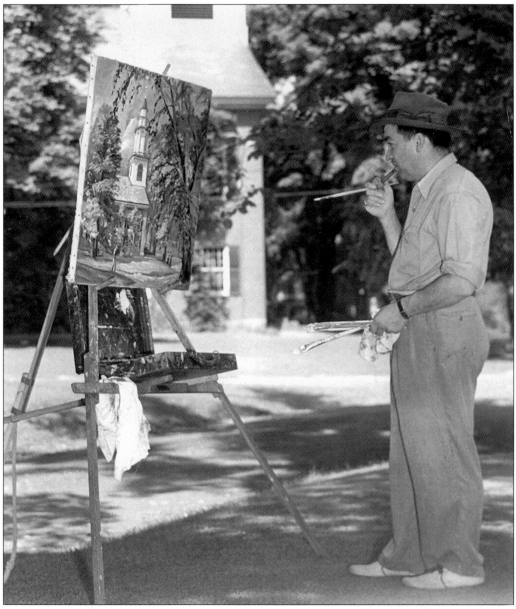

Well-known Deerfield artist Stephen Maniatty is shown painting *The Brick Church* in 1946. Maniatty lived and had a studio in a house at the north end of Main Street behind the Bardwell House. He also taught art in local schools. (Courtesy Peter S. Miller.)

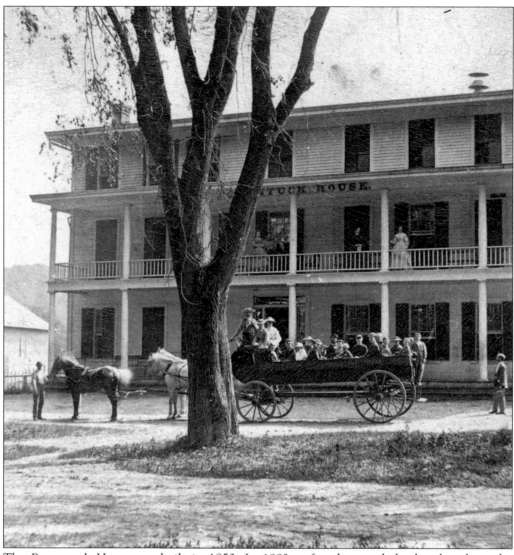

The Pocumtuck House was built in 1853. In 1883, a fire destroyed the hotel and, to the east, the Barnard Tavern. During the fire, the Indian House door was rescued. The Deerfield Academy Pocumtuck dormitory now occupies this site. (Courtesy Peter S. Miller; photographer Pelham Bradford.)

At the time of this *c.* 1890 photograph, Elizabeth Chapin probably owned the *c.* 1858 Arthur C. Hoyt House. In 1926, the academy purchased the house. In 1952, it was moved to the east and the Scaife dormitory was built on this site. (Courtesy Richard Arms and Mary Marsh; photographer Elliott W. Cook.)

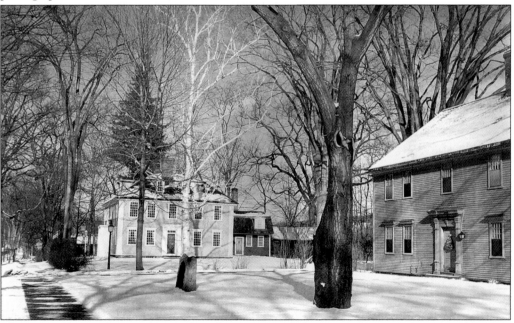

This view shows the nearby Mather dormitory and the next-door Joseph Barnard House, which houses the headmaster of Deerfield Academy. (Courtesy Peter S. Miller; photographer Kenneth Stinson.)

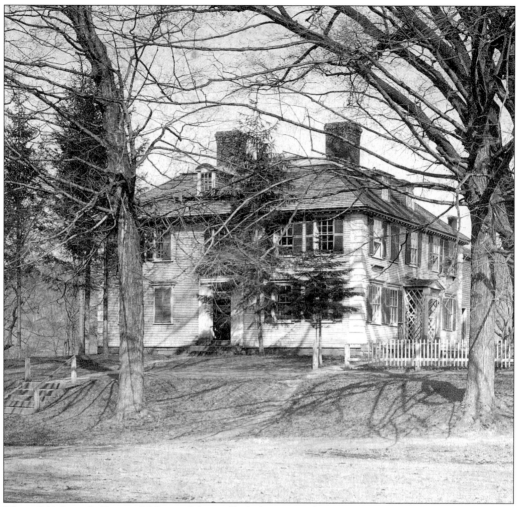

The 1768 Joseph Barnard House (also called the Manse) was at one time the home of Rev. Samuel Willard. Some remains of the very early house of Joseph Gillett may have been reused in the rear ell. In 1928, Deerfield Academy purchased the house. It is currently the home of the headmaster. (Courtesy Richard Arms and Mary Marsh.)

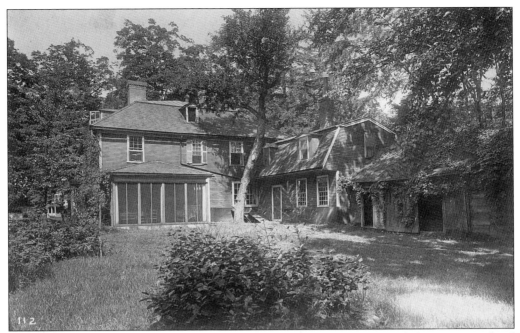

The rear of the Joseph Barnard House is shown in this *c.* 1910 postcard. (Courtesy Richard Arms and Mary Marsh.)

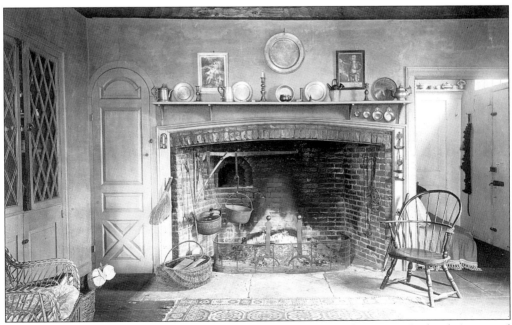

This *c.* 1910 postcard view is labeled "Dining Room Manse." (Courtesy Richard Arms and Mary Marsh.)

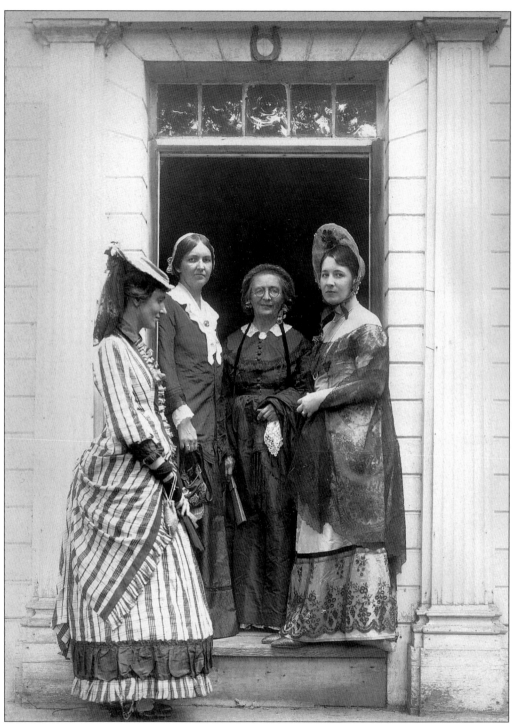

These costumed women are posing in the doorway of the Joseph Barnard House in August 1926. They are, from left to right, Elizabeth, Katharine, Mary W., and Anne Connell Fuller. The photograph is labeled "open house to raise money for fence at Laurel Hill Cemetery." (Courtesy Richard Arms and Mary Marsh.)

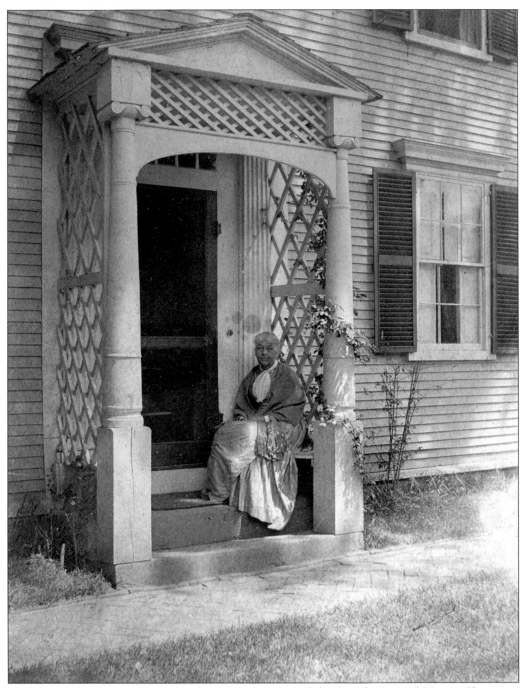

Madeline Yale Winn is sitting in the south doorway of the Joseph Barnard House. She was a member of the Yale locksmith family, formerly of Shelburne Falls. She summered in Deerfield and was very active in the arts and crafts movement in town. (Courtesy Richard Arms and Mary Marsh.)

This couple is thought to be sitting on the counter in Philo Munn's store. (Courtesy Peter S. Miller; photographer Ned Lamb.)

Philo Munn's store (built in 1870) was sold c. 1895 to Joseph E. Lamb, who had also purchased the Asa Stebbins House. Lamb's store once stood south of the present Hall Tavern building. In 1950, when the Hall Tavern was moved to this site, the small store came down. (Courtesy Peter S. Miller; photographer Ned Lamb.)

Ned Lamb (1882–1967), son of Joseph and Estella Lamb, lived in the Asa Stebbins House. Both he and his brother Edward were photographers. Ned Lamb was a lifelong photographer. He made postcards and probably shot a motion picture of the 1936 flood. Here, he is shown with his camera at the Greenfield Swimming Pool. (Courtesy Peter S. Miller.)

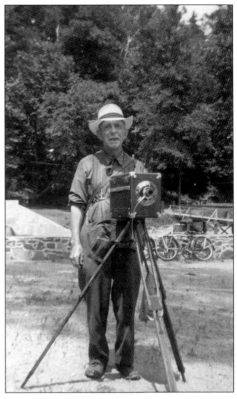

A woman stands in front of the old 1842 Town Street School (Grange Hall). This building once stood on the present site of the post office. In 1912, the building was moved to the Deerfield Academy campus and, in 1951, was torn down. (Courtesy Peter S. Miller; photographer Ned Lamb.)

43

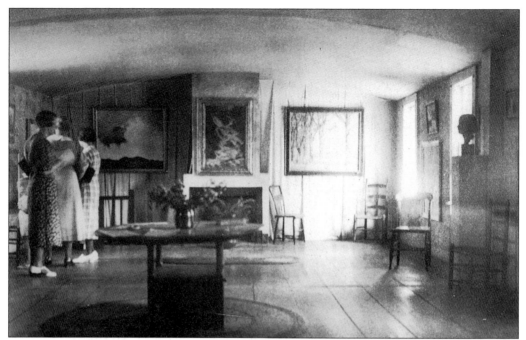

Many years ago, the Deerfield Valley Art Association held an art exhibit in the ballroom of the Hall Tavern when it was in East Charlemont. This picture depicts the now southern end of the upstairs ballroom. (Courtesy Richard Arms and Mary Marsh.)

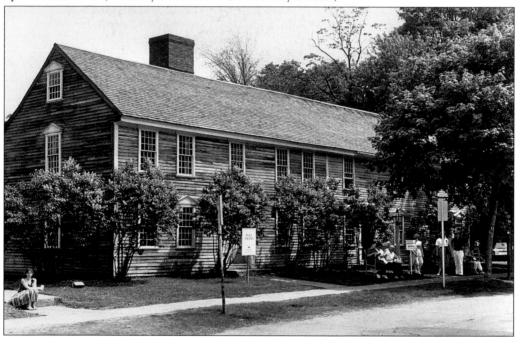

The c. 1765 Hall Tavern was originally located on the Mohawk Trail. After 1781, it became a tavern. In 1807, Joel Hall Jr. purchased the building, and it remained in the Hall family off and on until 1949. It currently serves as a visitor's information center for Historic Deerfield. (Courtesy the Recorder; photographer Paul Franz.)

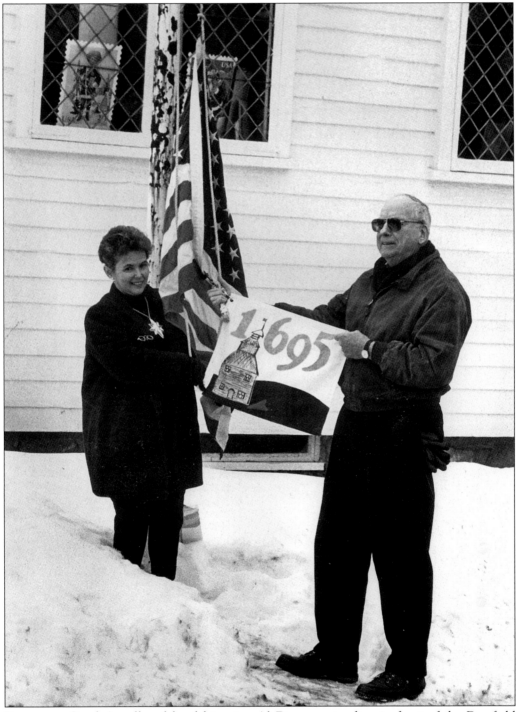

Postmaster Carol Angell and local historian Al Dray are standing in front of the Deerfield post office. They are raising a flag commemorating the 300th anniversary building of the first meetinghouse in Deerfield. (Courtesy the Recorder.)

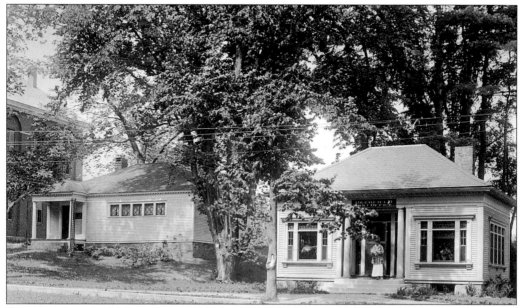

On the left is the Village Room (1896–1957), which was used for church suppers and as a library and meeting room. To the right is the post office, built in 1912 on the site of the former Grange Hall. (Courtesy Richard Arms and Mary Marsh.)

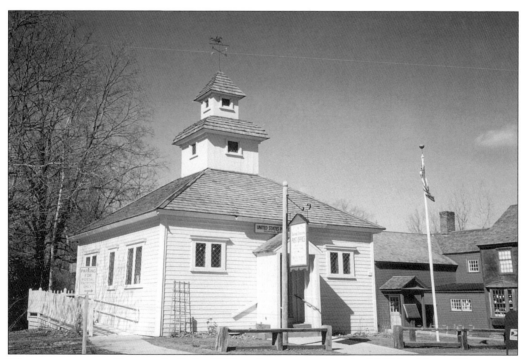

The present post office was built in 1912 and was remodeled in 1952 by Henry Flynt to be similar to Deerfield's third meetinghouse. (Photographer Kyle J. Scott.)

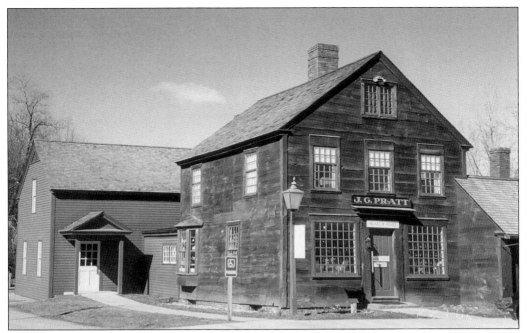

The J.G. Pratt House was turned into the Historic Deerfield Museum Store in 1995. Before it was a store, the house was used as a faculty residence by Deerfield Academy. (Photographer Kyle J. Scott.)

This photograph looks south from the Deerfield Inn toward the Brick Church. (Photographer Kyle J. Scott.)

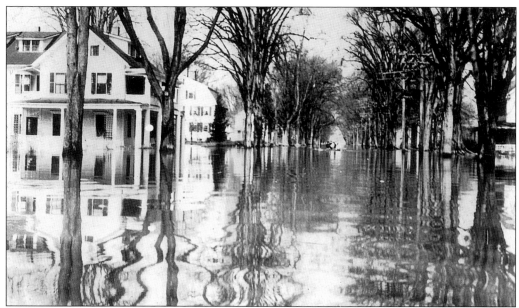

This picture, looking north, shows how high the water was during the 1936 flood. The other two great floods occurred in 1927 and 1938. The building on the left is the Deerfield Inn. Some people were taken directly out of their homes via boats. (Courtesy Peter S. Miller.)

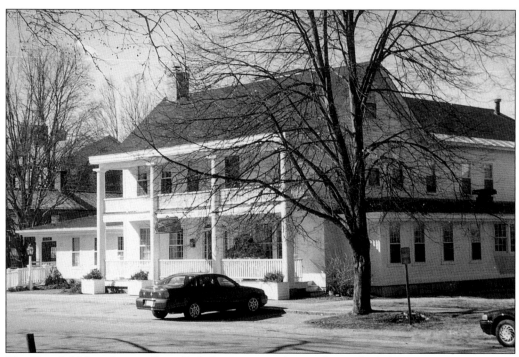

The Deerfield Inn (originally called the Pocumtuck Hotel) was built by George A. Arms in 1884. Henry and Helen Flynt purchased the hotel in 1945 as a place for the parents of Deerfield Academy students to stay. (Photographer Kyle J. Scott.)

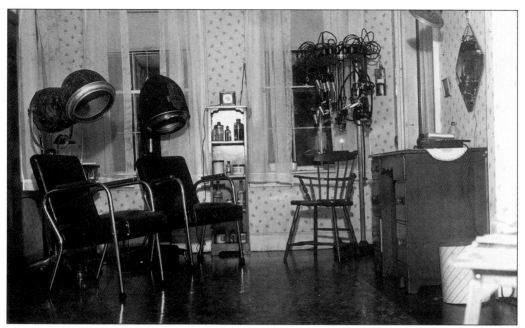

The caption on this postcard reads, "Our sitting room in Deerfield was Mrs. Annis beauty parlor." The photograph must have been taken in the mid-1930s. The Lamb family owned the Asa Stebbins House. They lived there and rented out rooms. (Courtesy Peter S. Miller; photographer Ned Lamb.)

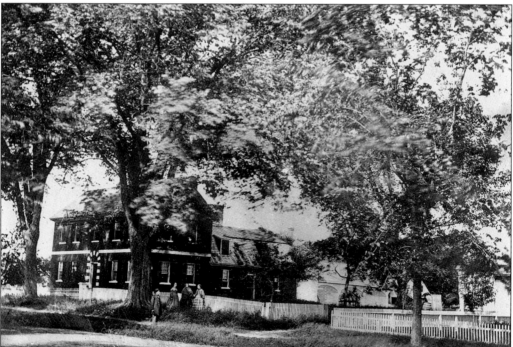

This post–Civil War view of the 1799 Asa Stebbins House reflects the influence of the Asher Benjamin–designed Deerfield Academy building. Note the gambrel-roofed rear ell. Henry Flynt purchased the house in 1946. (Courtesy Peter S. Miller.)

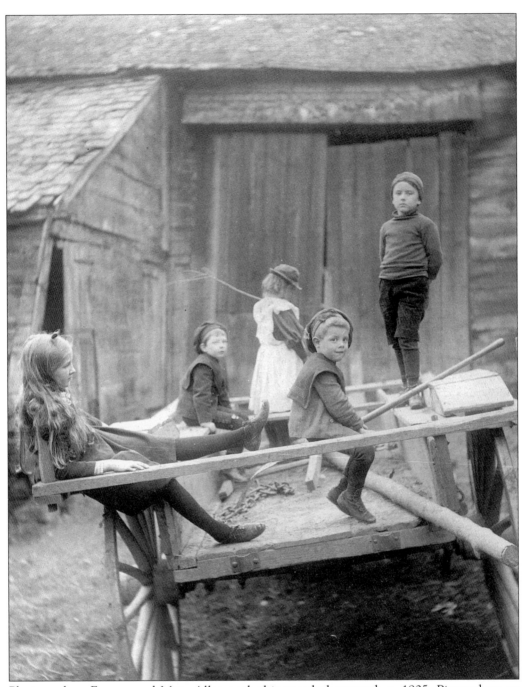

Photographers Frances and Mary Allen took this posed photograph *c.* 1905. Pictured on an ancient wagon in front of the Sheldon-Hawks barn are Katharine Fuller (left), George Fuller (right), David Solly, Bernard Solly, and an unidentified child. (Courtesy Richard Arms and Mary Marsh.)

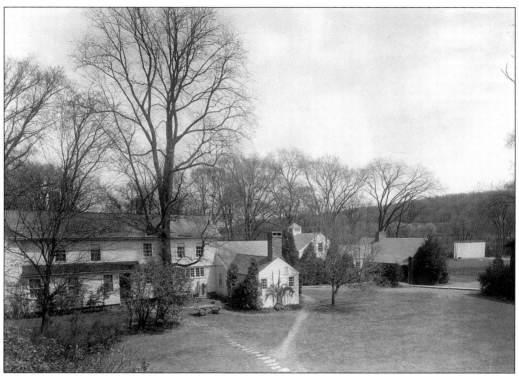

This view shows the back of the Severance-Hawks House and the grounds of the Bement School. (Courtesy the Bement School; photographer Robert D. Snivey.)

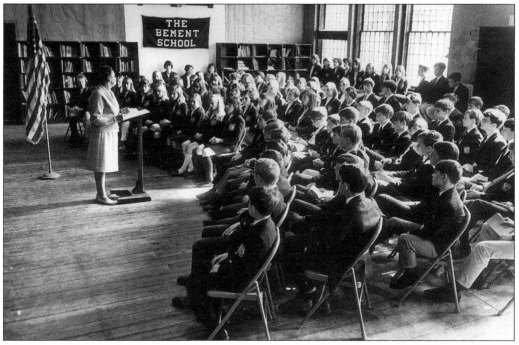

This assembly was held at the Bement School c. 1966. (Courtesy the Bement School; photographer George Woodruff.)

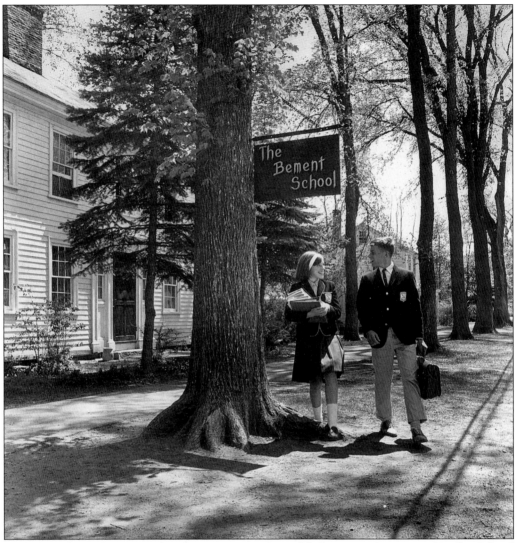

Two Bement students are shown *c.* 1966 in front of the 1712 Severance-Hawks School building. Grace A. Bement purchased the house in 1920 and, five years later, founded the school. The school is both a boarding school and day school for kindergarten through ninth grade. (Courtesy the Bement School; photographer George Woodruff.)

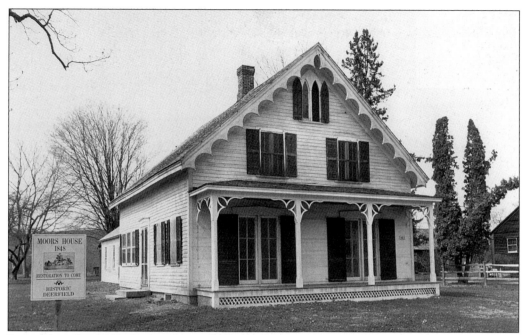

Pictured is the 1848 Gothic Revival house of Rev. John F. Moors. The house is currently undergoing a long-term restoration by Historic Deerfield. Moors was the minister at the Brick Church and, later, at the Greenfield Unitarian Church. The house was in the Ball family for 126 years. (Courtesy the Recorder; photographer Paul Franz.)

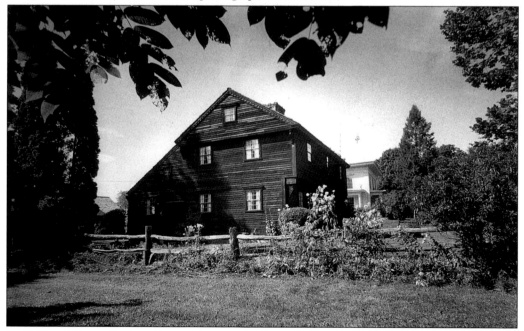

In 1929, William E. Gass Sr. and his son William E. Gass Jr. built this reproduction of the Indian House (the Ens. John Sheldon House). In 1932, the son removed the c. 1750 Bloody Brook Tavern in South Deerfield and rebuilt it behind the Indian House. (Courtesy the Recorder; photographer Bob Sterns.)

This *c.* 1955 view shows the David Dickinson House, built *c.* 1782. Above the door is a fake fan window with a real window insert. The Italianate John H. Stebbins House, built in 1858, is just to the south. In 1924, that house and diary farm were sold to Frank Yazwinski. It is still an operating farm. (Courtesy the Bement School.)

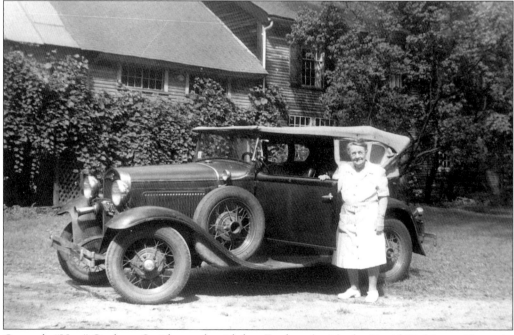

Gertrude "Hen" Cochran Smith stands with her Ford car beside the David Dickinson House in September 1955. She raised chickens. (Courtesy Richard Arms and Mary Marsh.)

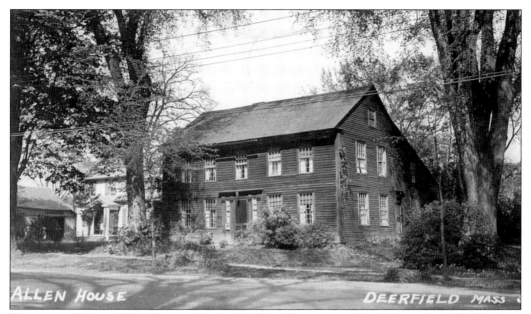

This view of the c. 1725 Thomas Bardwell–Allen House was taken before 1946. Well-known Deerfield photographers Frances and Mary Allen lived in the house and had their darkroom there. Henry and Helen Flynt, founders of Historic Deerfield, used this house as their Deerfield residence. (Courtesy Gerald Fortier.)

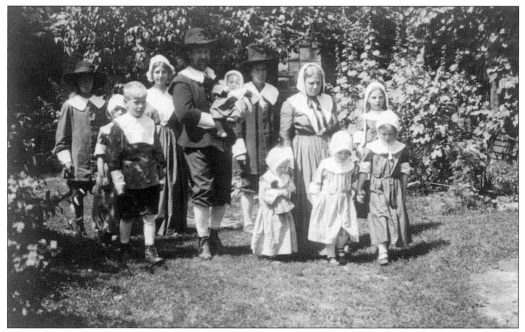

The Allen sisters were forever photographing pageants, landscapes, and posed scenes. (Courtesy Peter S. Miller.)

This is a view of the *c.* 1814 Joseph Clesson House (later the Parker and Russell Silver Shop) and the 1871 Cowles barn (later the Helen Geier Flynt Textile Museum). This gambrel-roofed building, meant to be an ell, was moved often. Henry Flynt moved it back to this site from Route 5 and 10. (Courtesy Peter S. Miller; photographer Ken Stinson.)

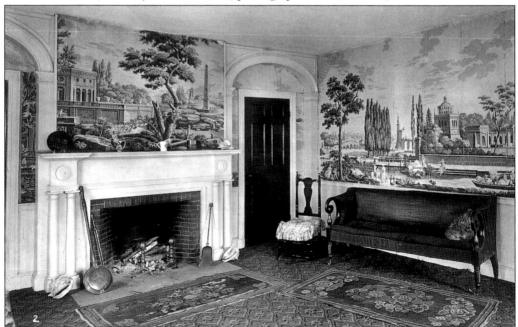

The formal north parlor of what was then the Cowles House is shown *c.* 1910. The *c.* 1816 wallpaper, printed in panels, is French and is original to the room. The sofa is also thought to be original to the room. (Courtesy Peter S. Miller.)

This *c.* 1980 photograph shows the Hinsdale-Williams-Cowles House and the 1824 Asa Stebbins Jr. House. Ebenezer Hinsdale built the front part of the *c.* 1750 house. In 1816, Ebenezer Hinsdale Williams greatly altered and enlarged the structure. The Cowles family lived here from 1866 to *c.* 1981. (Courtesy the Recorder.)

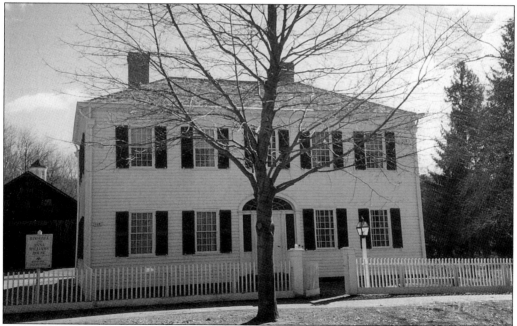

When Ebenezer Hinsdale Williams purchased this house, he raised the house up 18 inches in order to put the fan window above the door. He also raised up the roof. The Cowles barn is in the back. The Frank Boyden carriage collection is housed in that barn. (Photographer Kyle J. Scott.)

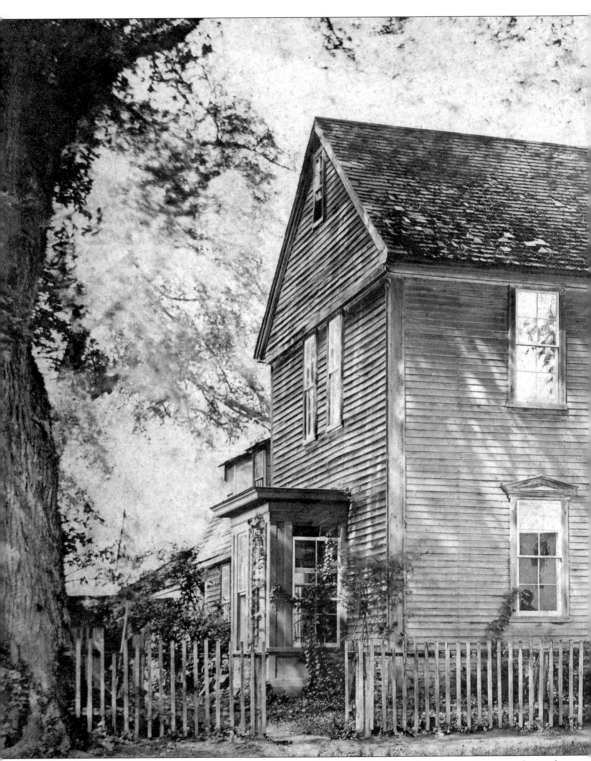

This *c.* 1890 photograph was taken in front of the Sheldon-Hawks House. It came from the estate of a widow of a descendant of George Sheldon. John Sheldon Jr. built the original ell to

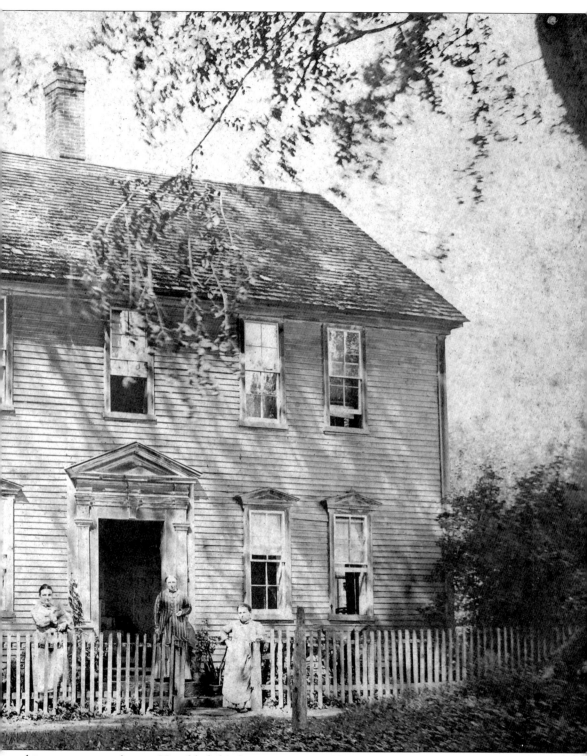

this structure as a house. He added the front section *c.* 1750. In 1802, the old ell was replaced with a larger ell that included two kitchens. (Courtesy Peter S. Miller.)

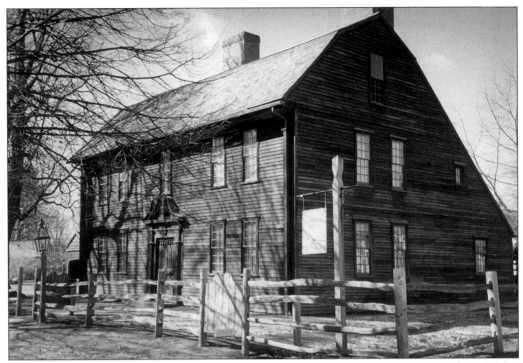

Thomas Wells constructed this house between 1726 and 1733. In 1733, Rev. Jonathan Ashley purchased the house. In the 1750s, he installed a gambrel roof and made other major changes. During the Revolution, Ashley was a loyalist. By 1869, this house became unfashionable, moved back to another location, and was turned into a barn. (Photographer Kyle J. Scott.)

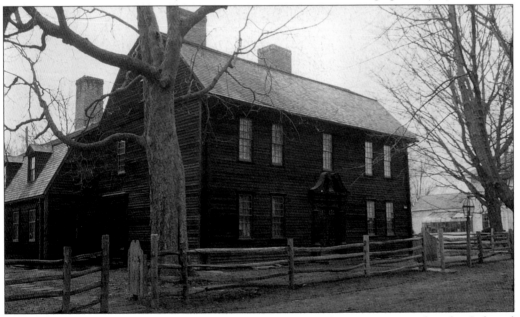

The Ashley home was the first Deerfield house that Henry Flynt reconstructed in the Colonial Revival style. In the spring of 1948, the house was first opened to the public. An apartment was added on to the back. (Photographer Peter S. Miller.)

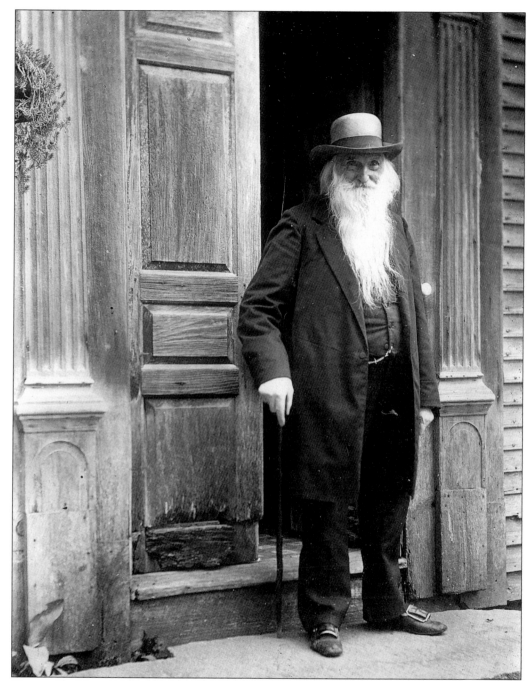

George Sheldon (1818–1916) is standing in the doorway of his home, the Sheldon-Hawks House. George Sheldon was in love with Old Deerfield and its history. He wrote a two-volume history of Deerfield. He was also a great gatherer of papers and artifacts to be put into what is now Memorial Hall Museum. Sheldon helped found and run the Pocumtuck Valley Memorial Association. He tried to save his ancestral home (the Indian House), but it was torn down in 1848. (Courtesy Pocumtuck Valley Memorial Association, Memorial Hall Museum, Deerfield, Massachusetts; photographers Frances and Mary Allen.)

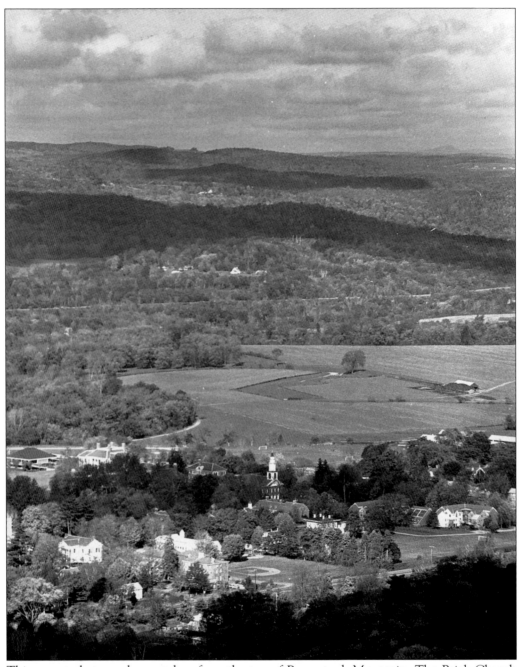

This recent photograph was taken from the top of Pocumtuck Mountain. The Brick Church is in the center of the photograph. Deerfield Academy is on either side of the church. In the background are cornfields. Interstate 91 is the line going across the center of the picture. (Courtesy the Recorder; photographer Paul Franz.)

Two

THE EAST DEERFIELD FREIGHT YARD AND OTHER RAILROAD SCENES

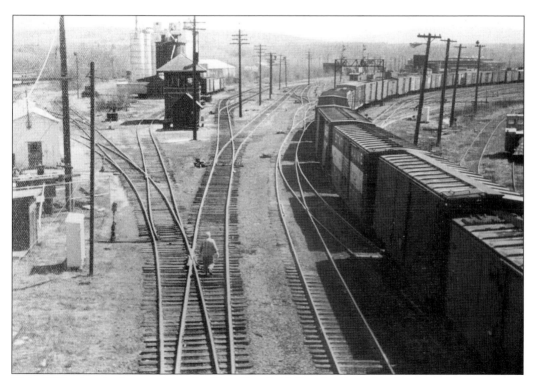

This 1973 view looks east into the East Deerfield Freight Yard. To the left of center is the tower from which railroad employees would direct yard traffic and rail traffic from Cheapside to Montague. The farm bureau was located in the white building in the background. (Courtesy Betty Hollingsworth.)

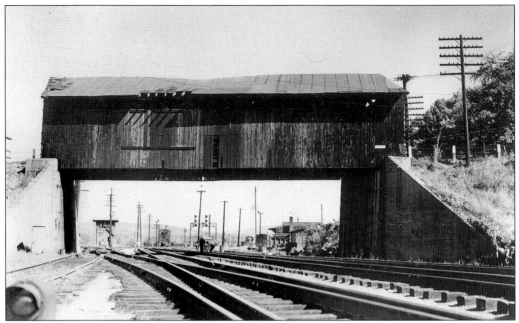

In this view looking east is the old covered bridge, which stood until c. 1952. At the center are the mainline tracks. In the back is the East Deerfield tower. The gasworks, the headquarters of the bridge, and building departments for the railroad are at the right. (Courtesy Peter S. Miller.)

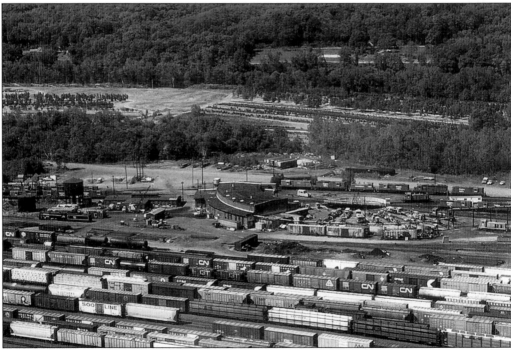

This 1985 photograph shows the remains of the old engine house at the East Deerfield Freight Yard. This area is now used to service mechanized track equipment. The old yard office is to the left. Note the steam engine in the center left that is there by chance. (Courtesy Peter S. Miller; photographer Kenneth E. Houghton.)

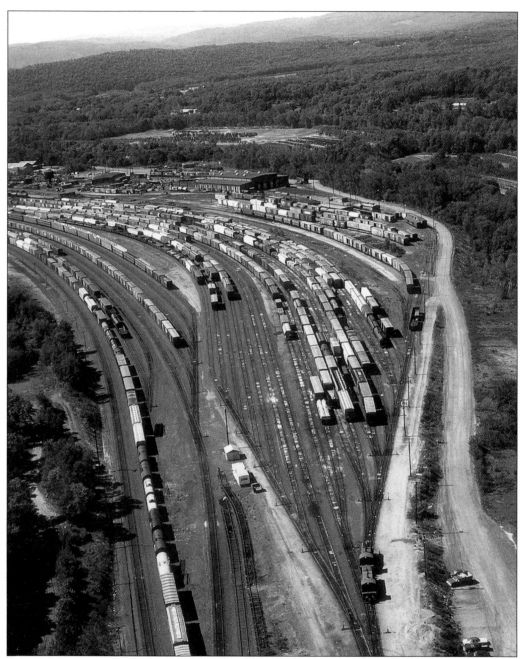

The East Deerfield Freight Yard is shown in a photograph taken from the eastern end. This yard dates from before the Civil War. After the Boston and Maine Railroad took over the Fitchburg Railroad in 1901, the yard was doubled in size. Later, c. 1920, the yard was again enlarged. The main lines through the yard are at the left. (Courtesy Peter S. Miller; photographer Kenneth E. Houghton.)

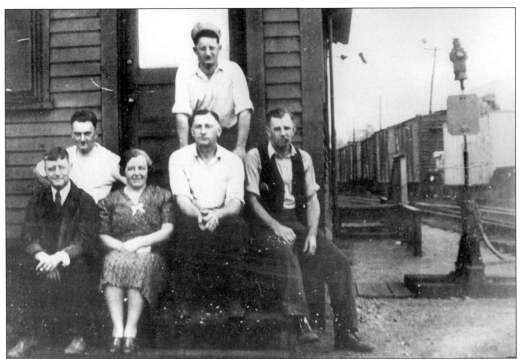

Posing in 1941 are some of the people who worked in the yard office. They are Harold Schwarz, Henry E. Kratz, Ed Ross, Pearl Couses, Ed Kock, and Avery Harrington. During the height of this freight yard, hundreds of people were employed here. (Courtesy the Historic Society of Greenfield.)

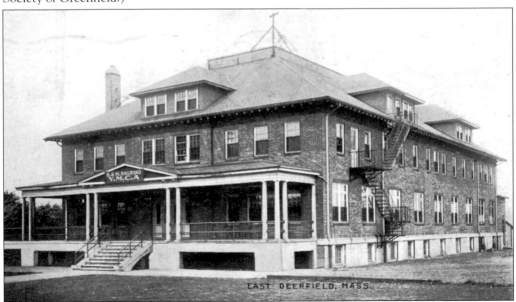

This is the second of two Boston and Maine Railroad buildings that were located in the East Deerfield freight yards. This one stood until c. 1973 at the western entrance to the yard at the curve beyond the bridge. It was originally built as a place for engine crews to sleep. (Courtesy Gerald Fortier.)

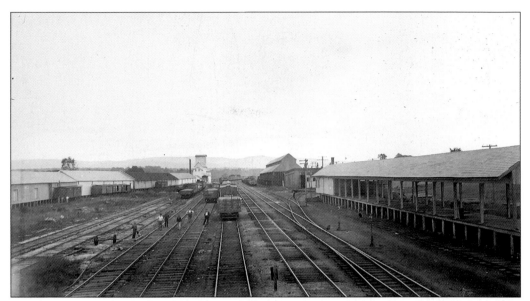

Orville C. Leonard, a railroad worker and photographer, took this photograph of the freight yard *c.* 1900. On the far right is an open dock for transferring freight from one car to another. The buildings on the left are for the storage of freight. (Courtesy the Historic Society of Greenfield; photographer Orville C. Leonard.)

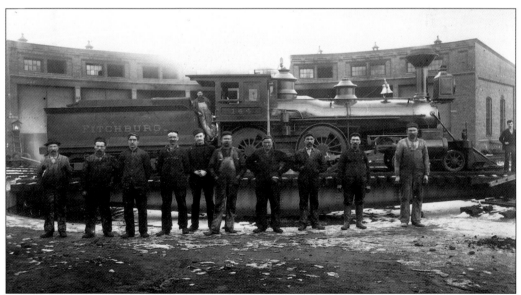

In this *c.* 1890s photograph, Fitchburg Railroad steam engine No. 144 (in service from 1887 to 1920) is on a turntable in front of the engine house. (Courtesy the Historic Society of Greenfield; photographer Orville C. Leonard.)

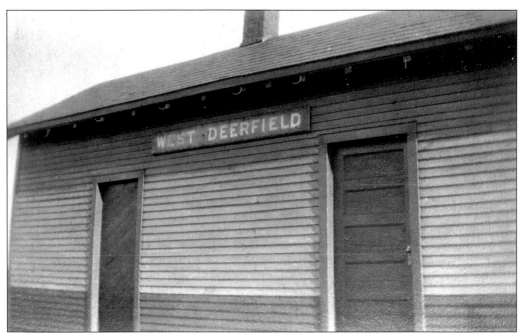

The West Deerfield railroad station was located next to the railroad overpass on the Upper Road in West Deerfield. (Courtesy Peter S. Miller.)

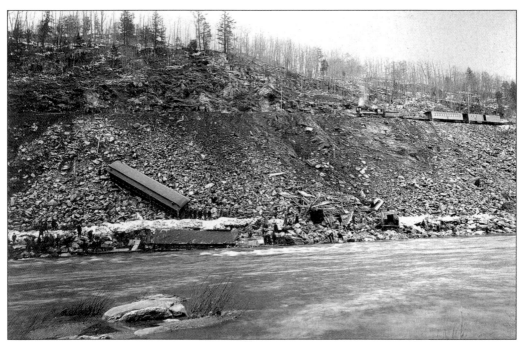

This photograph shows the April 7, 1886 wreck of eastbound train No. 35 on the Hoosac Tunnel Line of the Fitchburg Railroad. This accident happened very near the entrance of South River into the Deerfield River and east of Bardwell's Ferry in West Deerfield. About 10 people died. The track just gave way. (Courtesy Peter S. Miller; photographer Jonas K. Patch.)

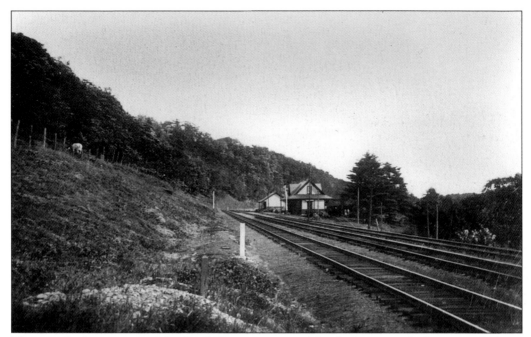

This view looks east toward the South River station and freight house on the Boston and Maine Railroad. This was the only station on the Boston and Maine that was not serviced by road. The stationmaster had to pedal a special bicycle on the rails two miles west in order to reach Bardwell's Ferry Road. (Courtesy Betty Hollingsworth.)

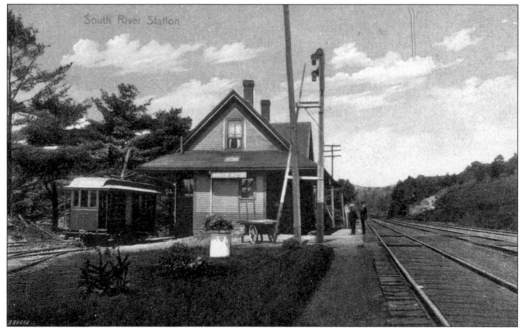

South River Station

The South River Boston and Maine station in West Deerfield was east of Bardwell's Ferry Road. The station was built just to service the Conway Electric Streetcar, which was once owned by the Boston and Maine. For freight services, the car line also used lightweight cars. The Deerfield River is just to the left of the station. (Courtesy Peter S. Miller.)

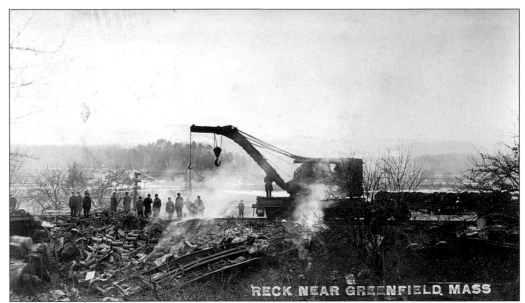

A railroad crane is at work near Deerfield Junction, just south of the Deerfield River. The wreck occurred in 1911 on the Connecticut River Line of the Boston and Maine Railroad. (Courtesy Peter S. Miller.)

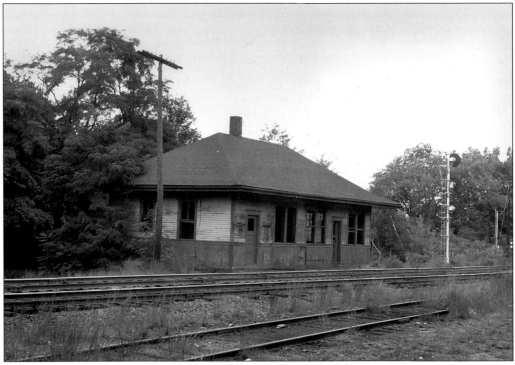

For years, Deerfield Academy students and Eaglebrook students used this Deerfield Boston and Maine station, which was abandoned by c. 1960. The former New York, New Haven, and Hartford Railroad station, at the end of Wells Street, was located down the hill slightly west of here. (Courtesy the Historic Society of Greenfield.)

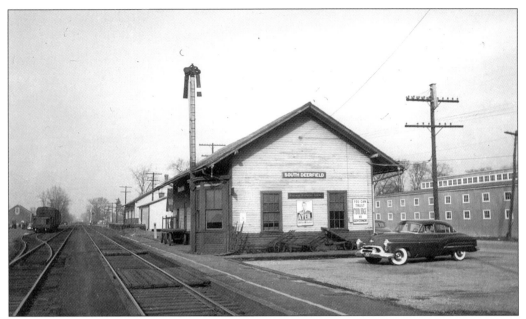

The South Deerfield Boston and Maine station is shown *c.* 1960 in a view looking north. This station was located on the east side of the tracks just north of Elm Street. The railroad gave up passenger service in the late 1950s, and these stations came down or were turned into other uses. (Courtesy Peter S. Miller.)

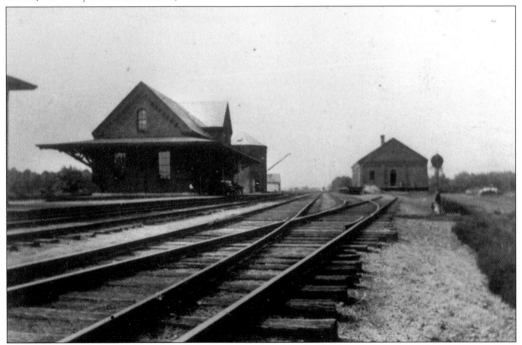

This is the New York, New Haven, and Hartford station in South Deerfield. This station's design was used in many other locations. It was here that the tracks split, with one line running to Shelburne Falls and the other to Turners Falls. In a violent windstorm during World War II, the station blew down. (Courtesy Betty Hollingsworth.)

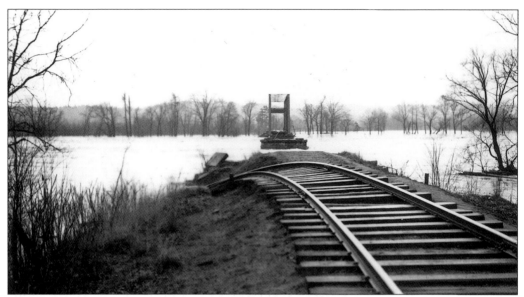

The 1936 flood was the worst of the three major floods of the 20th century. This flood took out the Montague City covered bridge, which in turn took out two of three of the New York, New Haven, and Hartford Railroad spans over the Connecticut River. This view looks toward East Deerfield from the Montague City end of the one remaining railroad bridge. (Courtesy Peter S. Miller.)

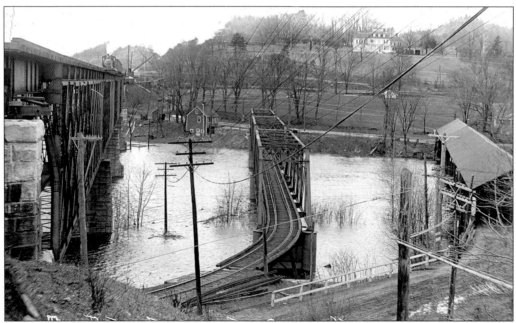

Shown c. 1911 are the famous three bridges over the Deerfield River: the railroad bridge, the trolley bridge, and the old Cheapside Covered Bridge. Only the bridge piers remain of the latter two bridges. (Courtesy Peter S. Miller.)

Three

SOUTH DEERFIELD

This is a 1973 view of the western entrance to South Deerfield. Today, drivers still have to cross over the railroad tracks. Mount Sugarloaf is in the background. (Courtesy Betty Hollingsworth.)

In this 1973 view of Elm Street, the white building in the center is Paciorek Market. John Krozkuski built the brick building on the right *c.* 1924. Kruk's grocery store was in the left side of the brick building. (Courtesy Betty Hollingsworth.)

In 1973, Chick's Luncheonette (on Elm Street) was in the center brick building. Today, Siena Restaurant is in this location. (Courtesy Betty Hollingsworth.)

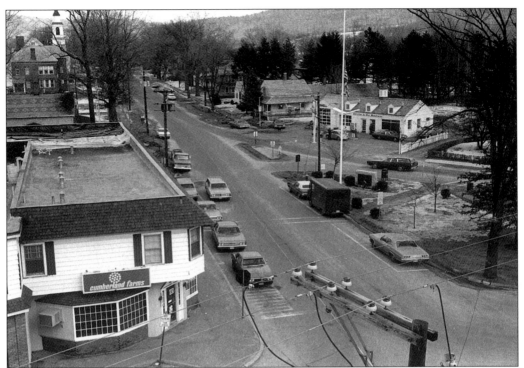

This *c.* 1973 view looks north from the Bloody Brook Inn. The old Deerfield Grammar School (the senior center and American Legion building) and the Congregational church are in the background. (Courtesy Betty Hollingsworth.)

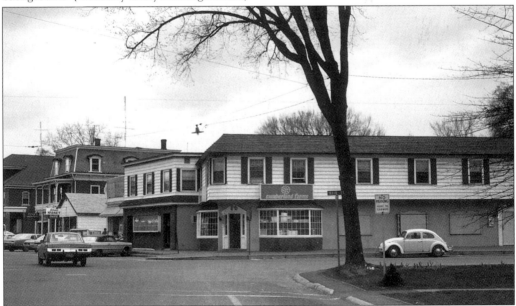

The structure on the corner is the *c.* 1951 new Bloody Brook Inn. Over a period of years, its appearance has changed many times. In the 1970s, the western end held the Bloody Brook Tavern, and Cumberland Farms occupied the center. The corner part once held a pharmacy and an ice-cream shop. (Courtesy Betty Hollingsworth.)

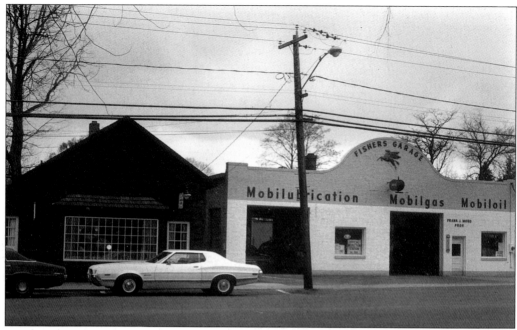

The building on the left of this *c.* 1973 photograph once held Phillips Fish Market and now houses the Charsky Insurance Agency. On the right is Fishers Garage (owned by George Fisher). The business started *c.* 1912. There was a fire *c.* 1934, and the garage was rebuilt. Frank and Donald Moro now operate the business. (Courtesy Betty Hollingsworth.)

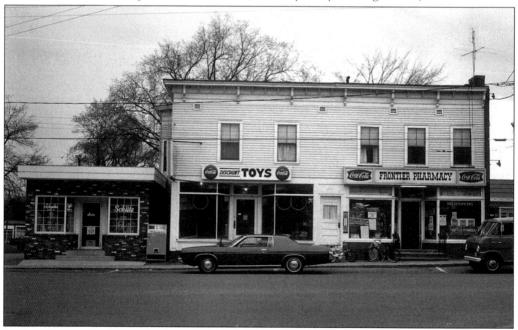

In *c.* 1973, the building on the left contained a liquor store. Billy Rotkiewicz operated the Frontier Pharmacy and a discount toy store in the white building. In another era, the Great Atlantic & Pacific Tea Company (A & P) and Billings Pharmacy once operated in the structure. (Courtesy Betty Hollingsworth.)

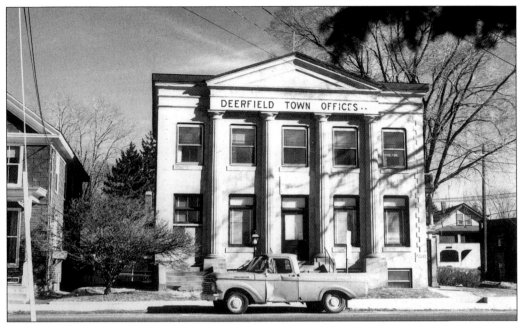

In 1973, the Deerfield town office was in the old Deerfield Produce Building. The bank was in this building for many years, and above it once was an apartment. The First National Bank and Trust Company of Greenfield took the bank over *c.* 1954. Over the years, many businesses were located in the building. (Courtesy Betty Hollingsworth.)

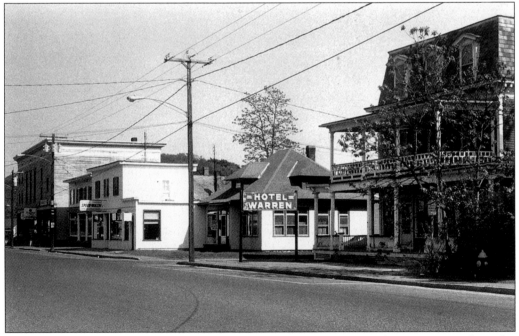

This is how the south side of Elm Street appeared in 1973. The Hotel Warren is on the right. This building, which dates from before the Civil War, was a way station for early travelers via wagon or rail. The low building is the barbershop of Gerald Fortier. At the far left is Redmens Hall. (Courtesy Betty Hollingsworth.)

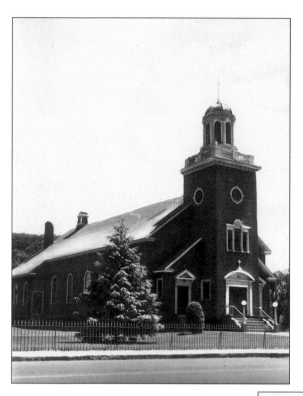

St. Stanislaus Roman Catholic Church was organized in 1908, and the property for the church was purchased in 1912. Church was first held in a rented hall on Elm Street . (Courtesy Peter S. Miller.)

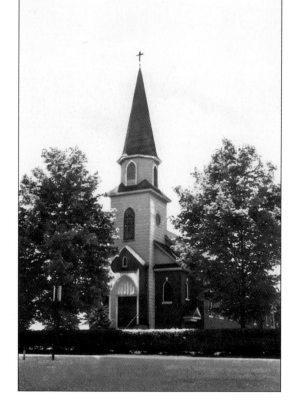

The Polish National Catholic Church (the Holy Name of Jesus Church) split off from St. Stanislaus c. 1929. The first church services were held in Redmens Hall. In 1930, the church was erected. (Courtesy Peter S. Miller.)

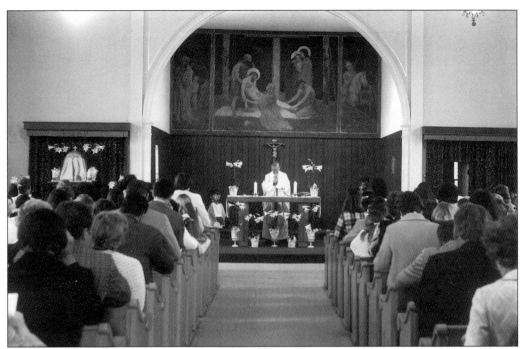

The mural in St. James Church was painted *c.* 1923 by Augustus V. Tack of Deerfield. The church was built *c.* 1847 as the Monument Congregational Church. It was located just east of the newer Bloody Brook Monument. The building was purchased by a Catholic organization in 1871. Then, *c.* 1895, it was moved and became St. James Church. (Courtesy Betty Hollingsworth.)

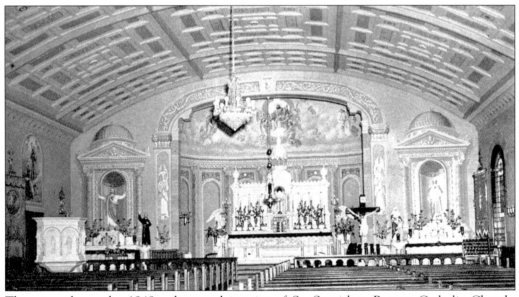

This view shows the 1948 redecorated interior of St. Stanislaus Roman Catholic Church. (Courtesy Gerald Fortier.)

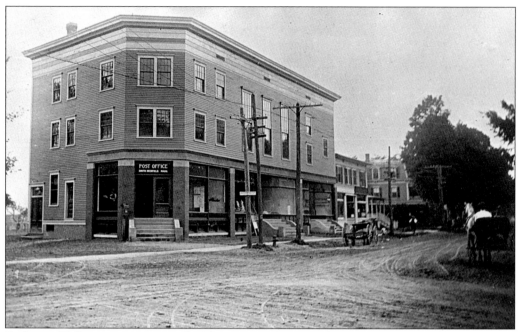

Redmens Hall was an important building in South Deerfield. Upstairs was actual hall. Town meetings and dances were held there. Movies were shown in the building. It was the largest assembly hall in Deerfield. In June 1978, the 69-year-old building was torn down. (Courtesy Gerald Foirier.)

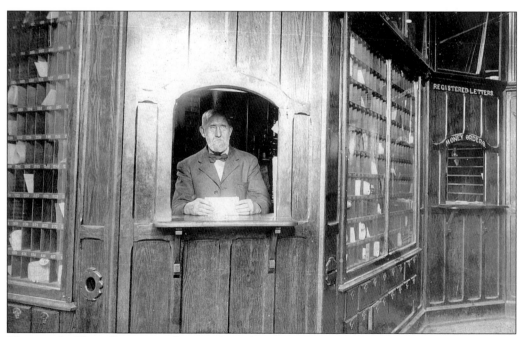

This may be Elmer Putnum at the postal window in Redmens Hall. The post office was located on the street level, and the postal window was opposite the door. (Courtesy Peter S. Miller.)

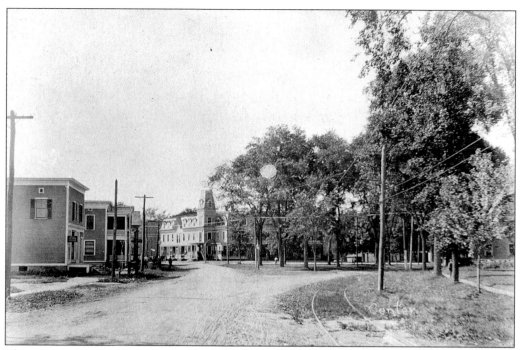

The common area is shown *c.* 1910. Note the trolley track to the right. The Lathrop Hotel is in the distance. (Courtesy Peter S. Miller.)

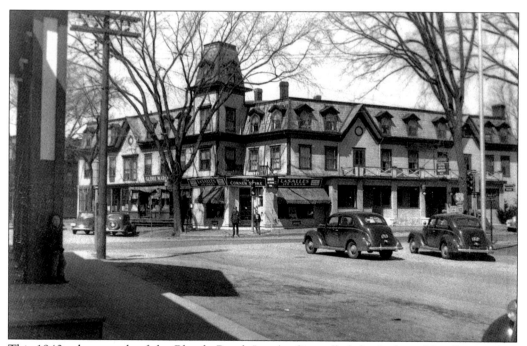

This 1940s photograph of the Bloody Brook Inn (earlier called the Lathrop Hotel) was taken a few years before it burned on March 14, 1951. The Globe Market is at the left. (Courtesy Gerald Fortier.)

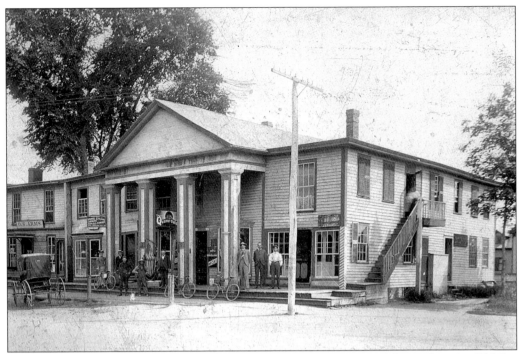

Old Put's Store was a true general store that offered a great variety of things for sale. Old Put was Elmer Putnam. The Cumberland store now occupies this site. (Courtesy Gerald Fortier; photographers A.W. and G.E. Howes.)

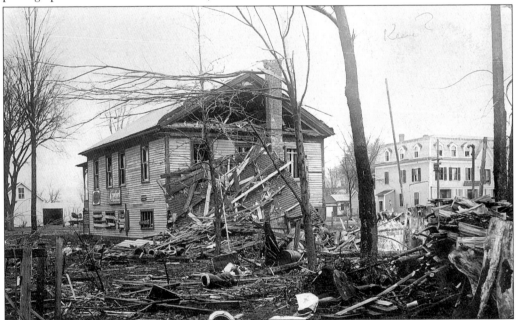

A gas explosion occurred on March 28, 1908, when three men with a lantern opened the gashouse door to investigate a gas leak. The building in the background is the Lathrop Hotel. The building in the foreground was owned by Paul Beaersoliet. (Courtesy Peter S. Miller; photographer Forbes.)

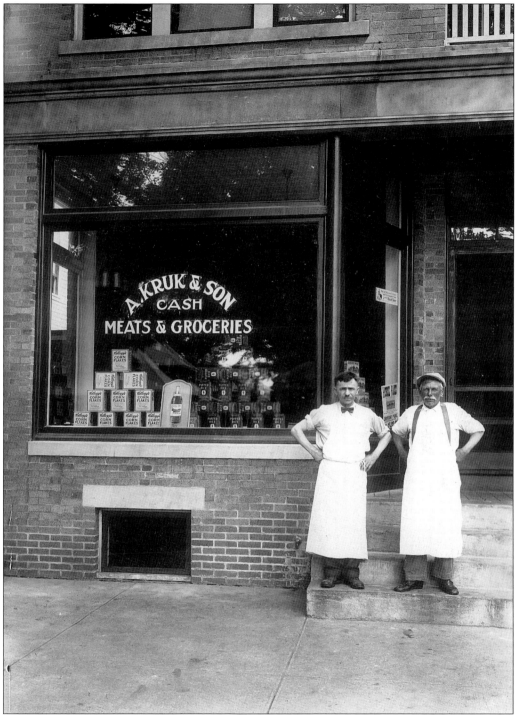

Anthony Kruk and his son, John Kruk, ran A. Kruk & Son grocery store in John Hrazkuski's new building on Elm Street. The children of Hrazkuski and Kruk married each other. Anthony Kruk, shown on the left, died in Poland, but his son stayed here. John Hrazkuski is on the right. (Courtesy John Kruk.)

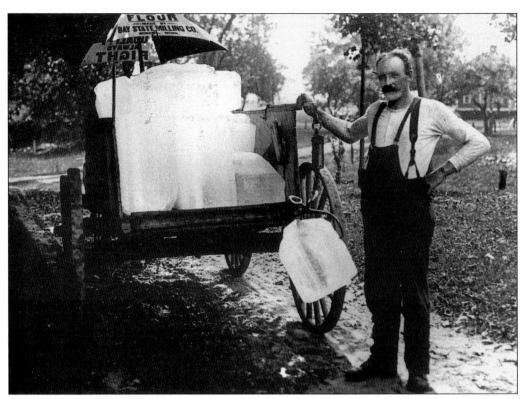

This c. 1920 photograph shows Fay Bratton weighing ice at the George Billings icehouse, located on the corner of Main Street and Hillside Road. (Courtesy Betty Hollingsworth.)

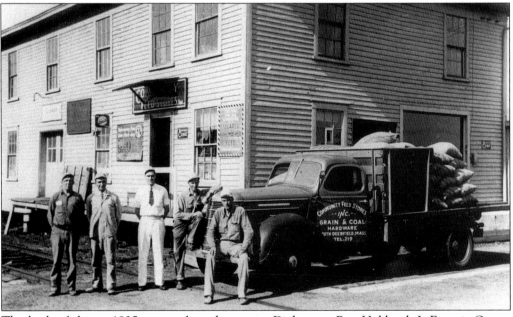

The back of this c. 1935 picture lists the names Dickerson, Ray Hubbard, J. Francis Gorey, Walter Sadowski Sr., and Gene Woods. Note the railroad tracks. The building is the Community Feed Store. (Courtesy Betty Hollingsworth.)

Members of the Electric Light Company stand with their truck on Sugarloaf Street. (Courtesy Betty Hollingsworth.)

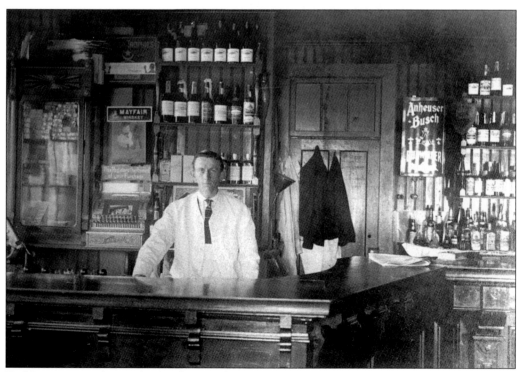

Tad Regan was a bartender for the Hotel Warren *c.* 1905. (Courtesy Betty Hollingsworth.)

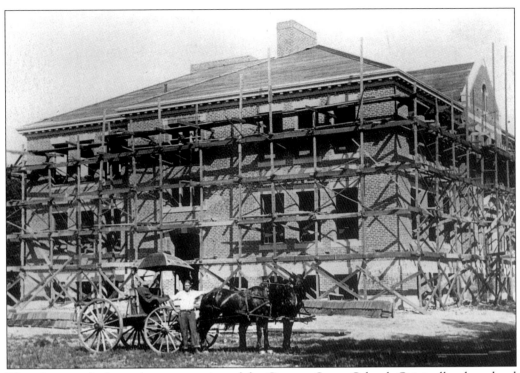

This photograph shows the construction of the Conway Street School. Originally, the school held classes for students in first through eighth grades, but it later served kindergarten through sixth grade. In 1996, the building was torn down to make way for the construction of the new town hall and police station. (Courtesy Betty Hollingsworth.)

The Deerfield High School was built in 1923–1925. In 1954, the Veteran's Memorial Gym was added to the back. In 1956, the Frontier Regional School section was added to the gym. The front of the building burned on February 1, 1957, but was later rebuilt. It was torn down in 1996, and a new section was constructed. (Courtesy Edna Stahelek.)

This is a procession of the bishop going into the Polish National Catholic Church. (Courtesy Gerald Fortier.)

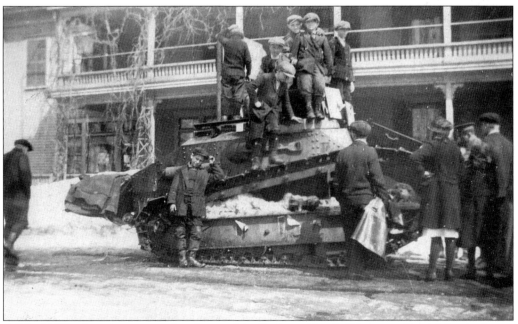

A World War I tank is pictured in front of the Lathrop Hotel. (Courtesy Gerald Fortier.)

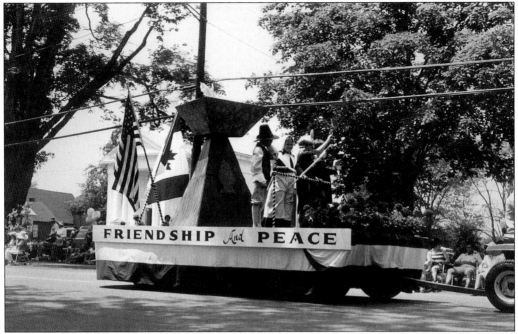

A copy of the bronze sculpture done by Homer Gunn of Greenfield for the 300th anniversary of the founding of Deerfield is sitting atop a float. (Courtesy Betty Hollingsworth.)

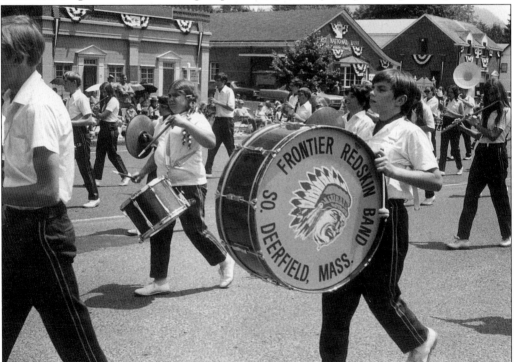

Members of the Frontier Redskin Band march up Sugarloaf Street on Sunday, July 8, 1973. The town of Deerfield held a large parade during its tercentennial celebration. (Courtesy Betty Hollingsworth.)

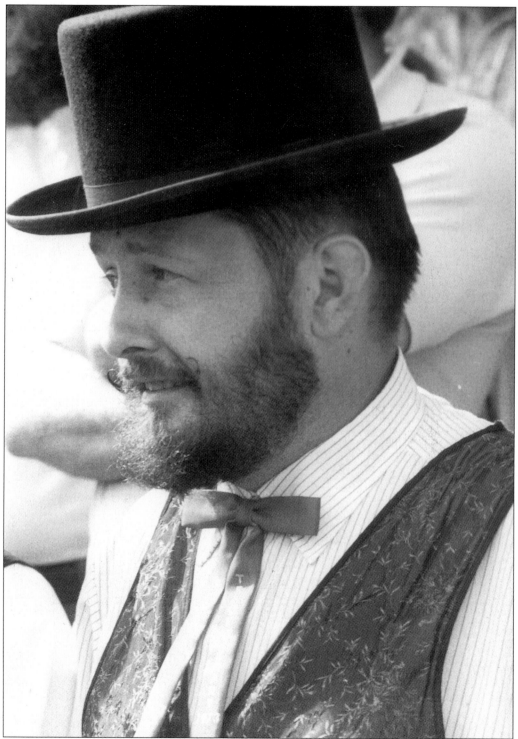

During Deerfield's 300th anniversary celebration, Anthony Ostrowski raised a beard for the beard-raising contest. (Courtesy Betty Hollingsworth.)

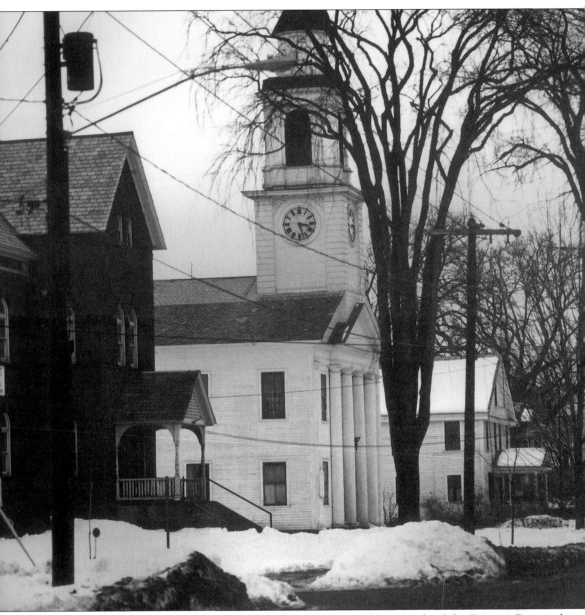

When this Congregational church was built, it was located just north of the Pioneer Regional High School. In 1825, the church was move via oxen and rollers to its present site. At that time, the one-story church had its top and sides raised and a balcony was installed. (Courtesy Betty Hollingsworth.)

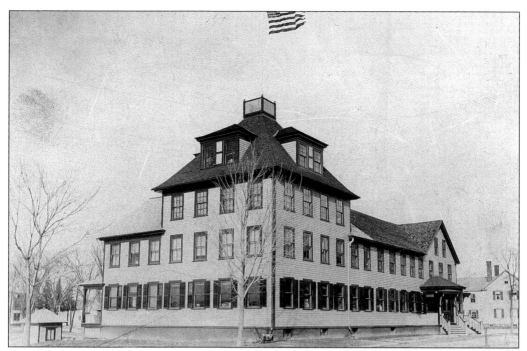

Dennis Arms founded the Arms Pocketbook Factory on Main Street in 1845. In 1889, the original factory burned and a new factory was built. For a while, the Deerfield Plastic Company was located here. Cowan Auto Supply currently occupies this site. (Courtesy Betty Hollingsworth.)

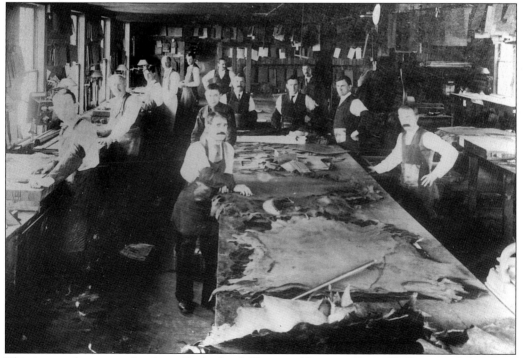

This is a workroom in the Arms Pocketbook Factory. (Courtesy Betty Hollingsworth.)

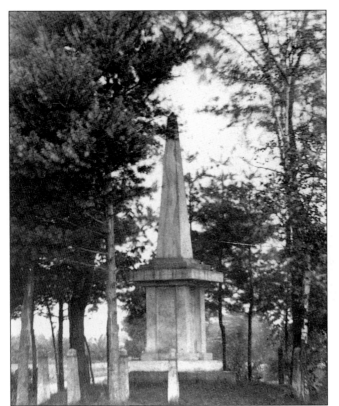

In 1838, Martin Woods of Sunderland designed this marble obelisk. It commemorates the September 18, 1675 killing of 76 Englishmen. Some 96 Native Americans also died. The event represented the greatest number of Englishmen killed at one time during King Phillip's War. This photograph dates from c. 1867. (Courtesy Peter S. Miller; photographers Horton and Wise.)

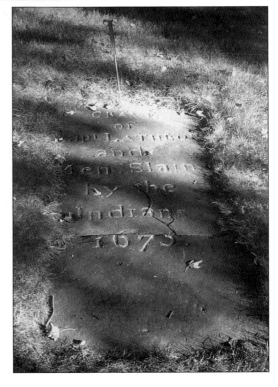

It is thought that the original Bloody Brook Monument, placed here in the very early 18th century, was a tabletop monument supported by bricks. The capstone, now in two pieces on the ground, measures three by five feet. The stones are in the yard of a Main Street house. (Photographer Peter S. Miller.)

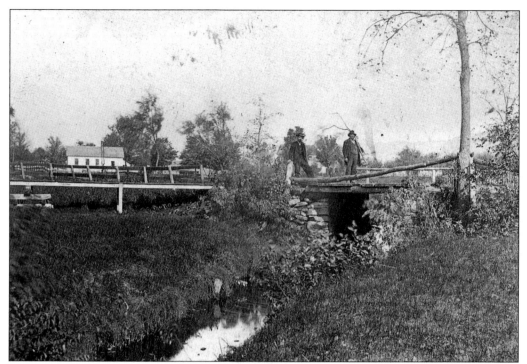

This *c.* 1870 view shows the bridge over Bloody Brook. During the September 18, 1675 battle, the brook ran red with blood—hence, the name. (Courtesy Peter S. Miller; photographers Lovell and Knowlton.)

During the early 1900s, Deerfield had a lot pageants, and at least one silent movie was made in town. This photograph may be a scene from the movie—the 1675 ambush by the Native Americans at Bloody Brook. (Courtesy Peter S. Miller.)

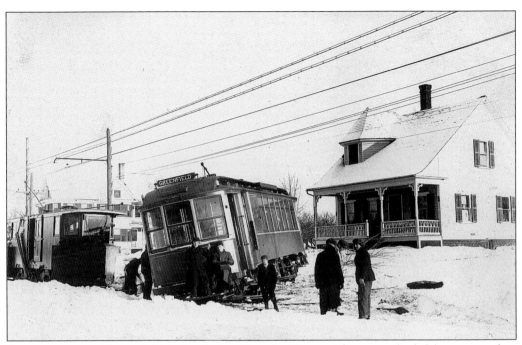

A streetcar named Greenfield is derailed on Sugarloaf Street. The car to the left has a snowplow on the front. (Courtesy Peter S. Miller.)

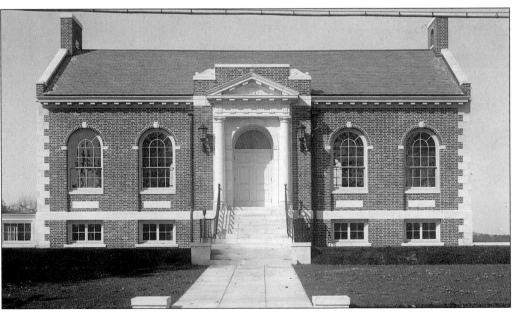

The Tilton Library was built on Main Street *c.* 1917. For many years, Nancy Bell ran the Dickinson Library in Old Deerfield. (Courtesy Peter S. Miller.)

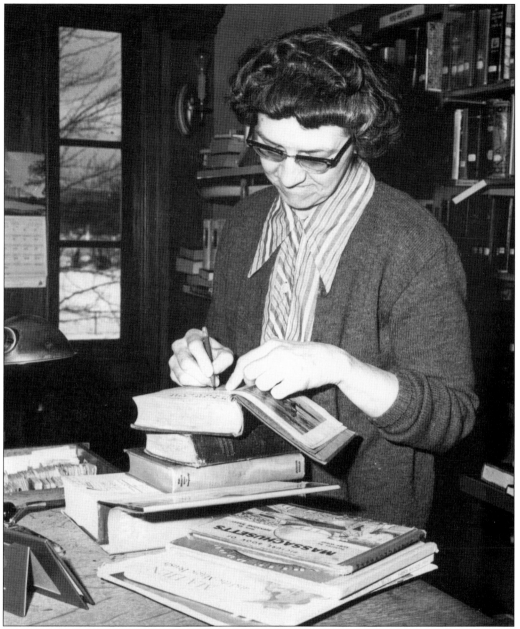

For about five or six years, Gertrude Dzenis worked as the assistant librarian in the Tilton Library. (Courtesy Betty Hollingsworth.)

On September 24, 1867, J.L. Lovell of Amherst went to the top of Mount Sugarloaf to photograph the 1864 Summit House. At the house was a telescope. (Courtesy Peter S. Miller; photographer J.L. Lovell.)

This is the old Forbes Tollhouse, located on the Sunderland side of the Connecticut River Bridge. (Courtesy Betty Hollingsworth.)

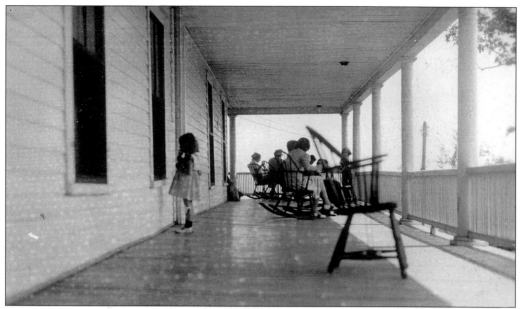

On the porch of the Summit House atop Mount Sugarloaf, many people loved to sit and enjoy the great view of the Connecticut River Valley. (Courtesy Peter S. Miller; photographer Ned Lamb.)

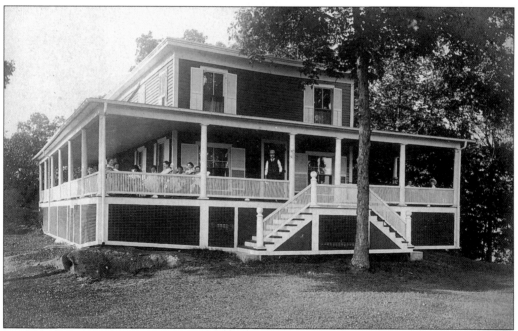

In 1908, the original c. 1864 Summit House was in bad shape. It was decided to incorporate the old structure as a part of another newer building. The Civilian Conservation Corps built a road to the top of Mount Sugarloaf c. 1939. On Election Day of 1966, a nighttime fire destroyed the Summit House. (Courtesy Peter S. Miller.)

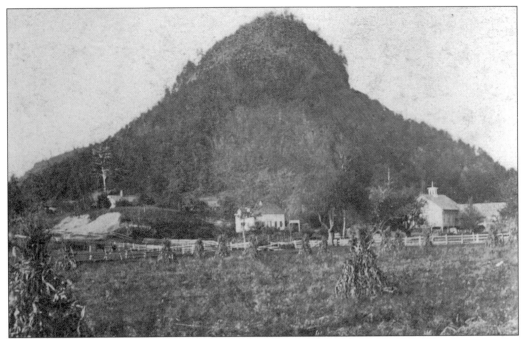

Mount Sugarloaf got its name from the fact that early settlers of the valley thought the mountain looked like a loaf of sugar. This photograph was probably taken in the early 1870s. The valley below contains some of the best farming land in the world.

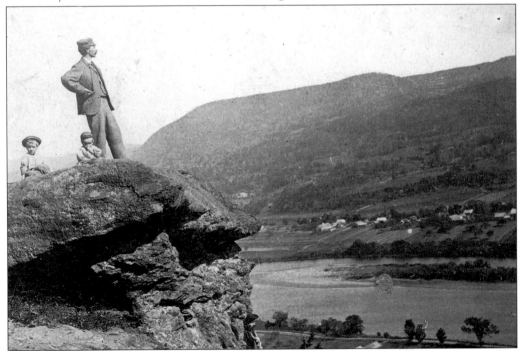

A photographer stands on King Phillip's Rock atop Mount Sugarloaf c. 1870. He is looking across the Connecticut River to Sunderland. (Courtesy Peter S. Miller; photographers Houghton and Knowlton.)

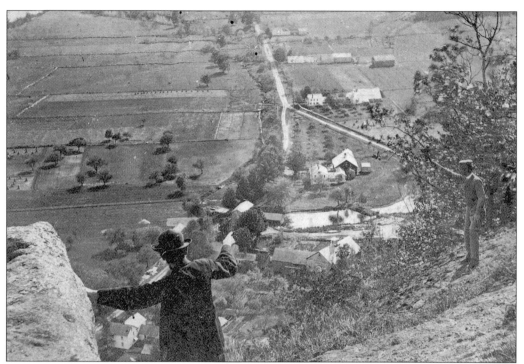

The man in the foreground is probably the photographer, standing in front of the camera to give depth to this *c.* 1870 stereopticon photograph. The view is of River Road to Whately. The river is to the left. (Courtesy Peter S. Miller; photographers Knowlton Brothers.)

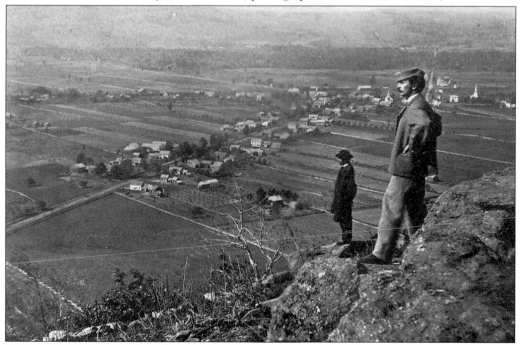

This great view of South Deerfield was taken *c.* 1870 from atop Mount Sugarloaf. (Courtesy Peter S. Miller; photographers Lovell and Knowlton.)

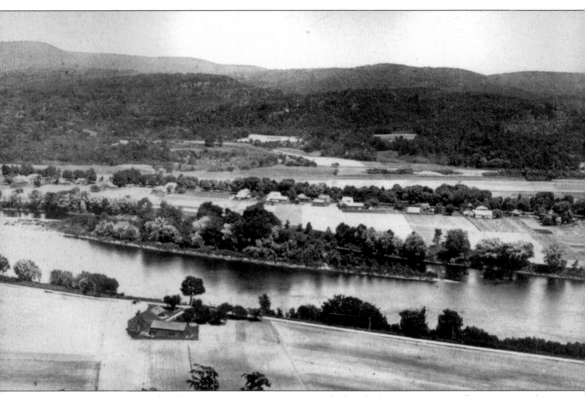

Looking east across the Connecticut River into Sunderland, this two-postcard view was taken sometime before 1936 from Mount Sugarloaf. The view from this mountain is spectacular and

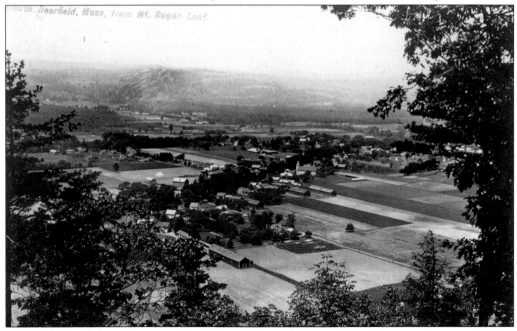

Behind some of these houses in South Deerfield are fields used for planting tobacco and other crops. (Courtesy John Kruk.)

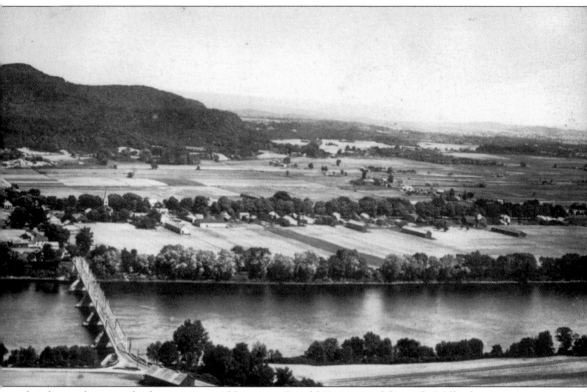

has been photographed many times. (Courtesy Gerald Fortier and Peter S. Miller.)

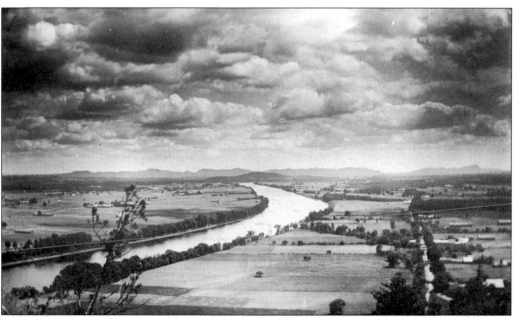

This postcard, looking south from Mount Sugarloaf, dates from 1922. The Connecticut River divides the towns of Sunderland (left) from the town of Whately (right). (Courtesy Peter S. Miller.)

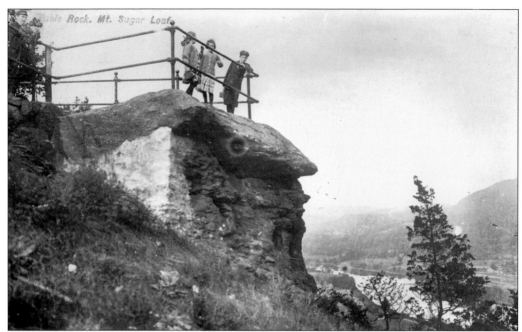

Young people are shown at the famous lookout point on Mount Sugarloaf. This postcard is dated July 13, 1915. (Courtesy Leonard Galisa.)

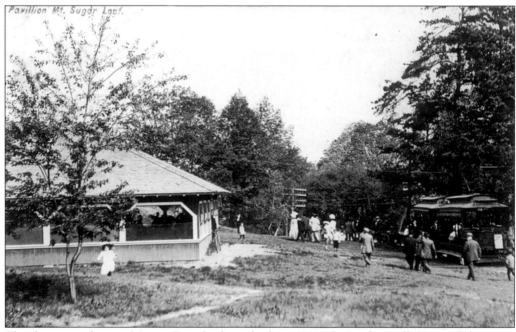

The dance pavilion at Mount Sugarloaf was built c. 1910. Since the trolley ran to this spot, people came from all over to go dancing there on Saturday nights. It was located on one of the old S-curves on the road to the bridge. In 1946, it was torn down. Some of the wood was used in the construction of Thayer's Market. (Courtesy John Kruk.)

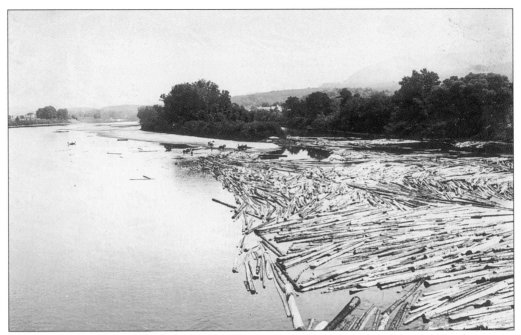

For many years, logs floated down the Connecticut River to the oxbow in Northampton. This *c.* 1910 photograph shows some logs and loggers above the Sunderland Bridge. (Courtesy Peter S. Miller.)

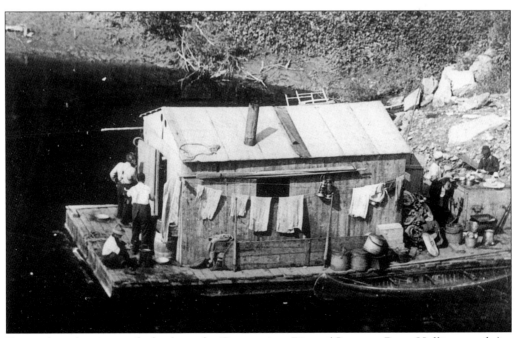

Pictured is a logging cook shack on the Connecticut River. (Courtesy Betty Hollingsworth.)

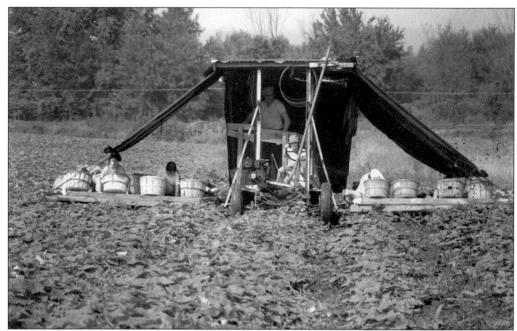

Many local children have had the pleasure of picking cucumbers for use in the Oxford pickle factory. (Courtesy Betty Hollingsworth.)

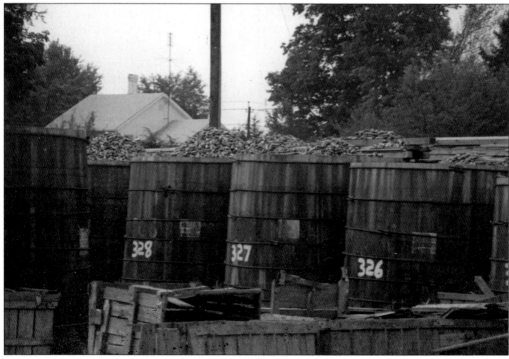

These pickle barrels are behind the Oxford pickle factory. The cucumbers are kept for a period of time in salt brine. In 1896, in this location, Alvord Jewett founded the company. In April 1948, fire destroyed the entire plant. By 1950, the plant had been rebuilt. Later, the John E. Cain Company took over the plant. (Courtesy Betty Hollingsworth.)

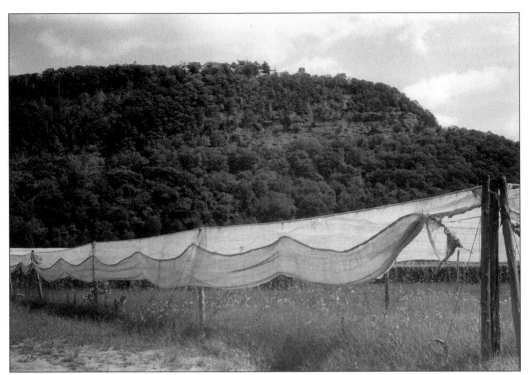

These are fields used for the growing of shade tobacco. This type of tobacco is used for wrapping cigars. For years, many teenagers worked in these fields. In the background is Mount Sugarloaf. (Courtesy Betty Hollingsworth.)

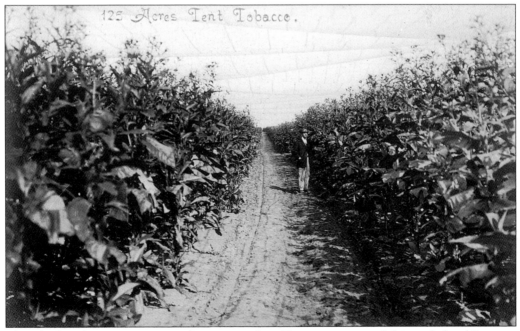

This shade tobacco is grown under netting that filters out some of the sunlight. (Courtesy Peter S. Miller.)

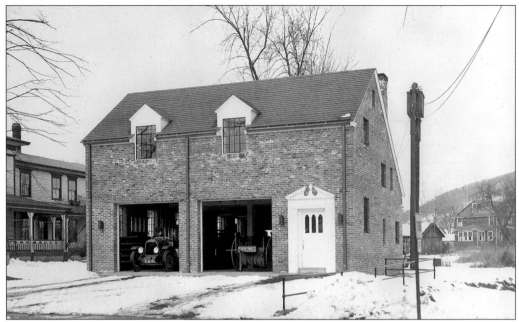

Pictured is the second South Deerfield District Fire House (1936–1993), on Sugarloaf Street. The first meeting of the South Deerfield Hook and Ladder No. 1 occurred on March 17, 1892. The hose house was built in 1892. In 1904, a second company was formed. (Courtesy South Deerfield Fire Department; photographer Alex M. Gamlin.)

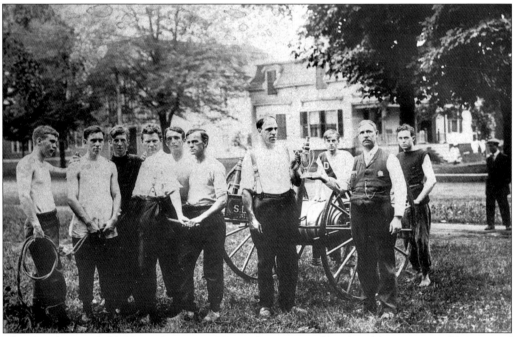

The South Deerfield Hose Company No. 1 team is gathered at the corner of Main and Conway Streets. Pictured are Chick Arms, Ray Arms, Evard Jewett, "Little" Tom Ahern, Sam Delano, Edgar French, Louis Arms, Charles Dean, John Eavener, and Harry Brown. (Courtesy Betty Hollingsworth.)

Four

OTHER SECTIONS OF DEERFIELD

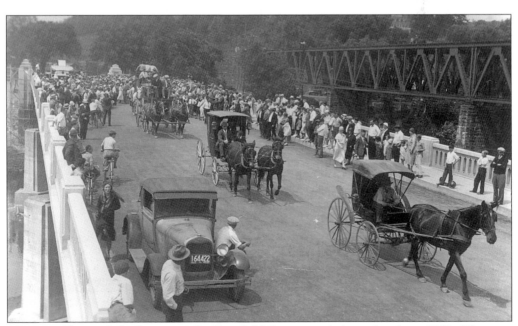

The new Cheapside bridge across the Deerfield River was dedicated in June 1932. (Courtesy Peter S. Miller.)

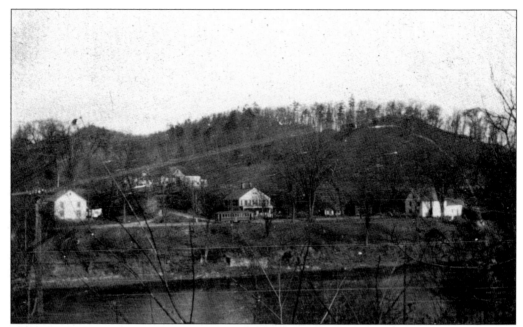

This view looks across the Deerfield River to the Cheapside section of Greenfield. Until 1896, this section of Greenfield was part of Deerfield. Near the river is a stone pier, a reminder of the river port days. Just above to the left is the juncture of Hope and Cheapside Streets. (Courtesy Peter S. Miller.)

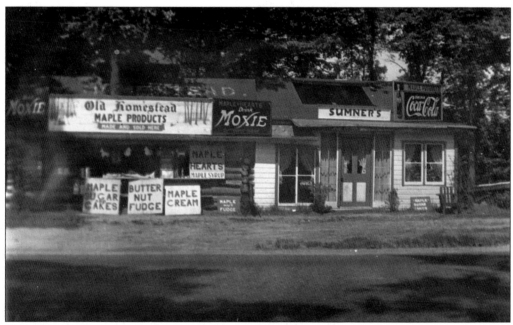

The Old Stand was run by George H. Sumner. He had a 99-year lease from Ned Lamb of the Asa Stebbins House. On the new Route 5 and 10, Sumner built a log cabin that had a tree growing through the roof. The company made and sold maple products, and the Sumners lived in back. (Courtesy Peter S. Miller; photographer Ned Lamb.)

This photograph of the northern entrance to Deerfield was taken on February 13, 1950. (Courtesy Deerfield Police Department; photographer Edward A. Sirick.)

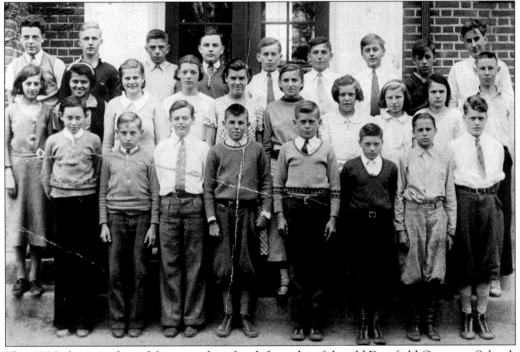

This 1935 photograph is of the seventh and eighth grades of the old Deerfield Grammar School. At that time, there were two grades to a classroom. Jessie Melnik is in the middle row, third from the left. (Courtesy Jessie Melnik Ruschmann.)

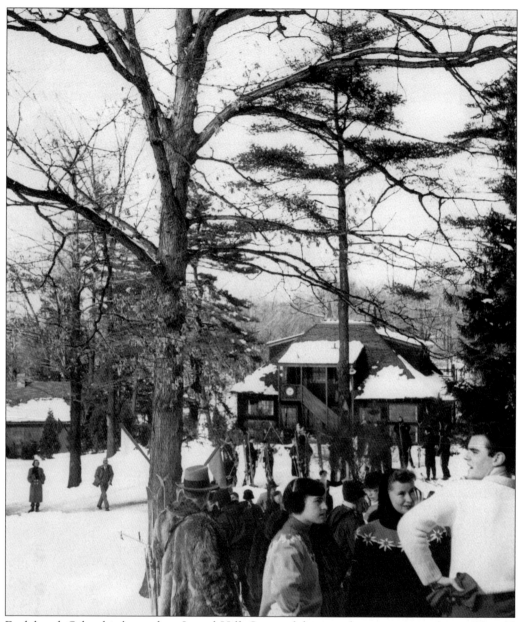

Eaglebrook School is located on Laurel Hill. Some of these students are going skiing. The old lodge is in the background. The present king of Jordan and his brother went to school here. The king also graduated from Deerfield Academy. Eaglebrook School offers grades six to nine. (Courtesy Eaglebrook School.)

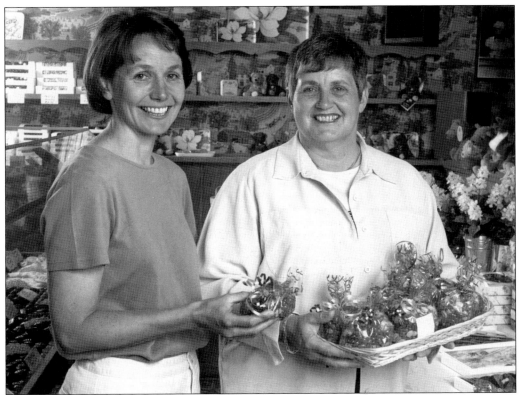

Richardson's Candy Kitchen, located on Route 5 and 10 in Old Deerfield, has been at the same location for more than 40 years. The store features light quality chocolates and specialty candies. Workers Kathie Williams (left) and Barbara Woodward (right) carry on a 50-year tradition of custom candy making. (Courtesy Richardson's Candy Kitchen.)

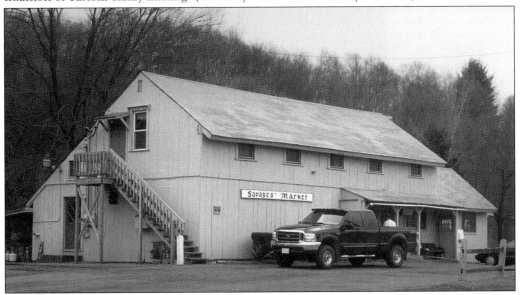

Just below Old Deerfield is Savage's Market. It is a great place to pick up something to eat, do some light shopping, or grab a cup of coffee. (Photographer Peter S. Miller.)

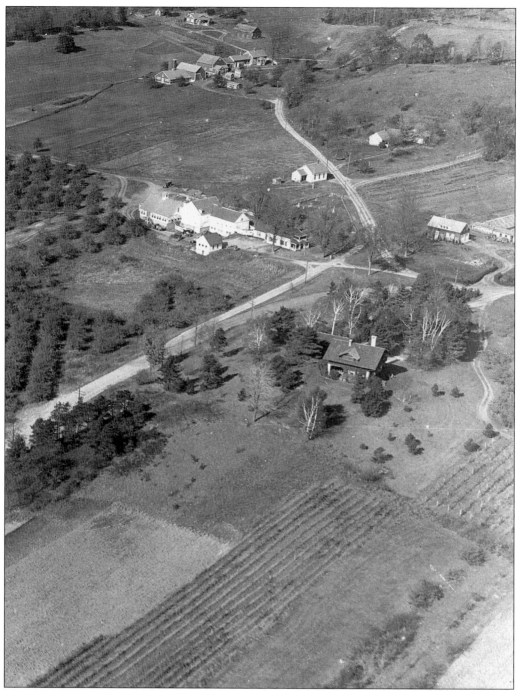

This part of the Wisdom district of West Deerfield is at the corner of Old Albany and Upper Roads. The lower house was the home of Dr. Webster Clark. The farm at the left is Clarkdale Apple Orchard. To its rear is the old district schoolhouse. The next farm up on the right of the road is the Winn Farm. (Courtesy Fred Clark; photographer Alex Gamelin.)

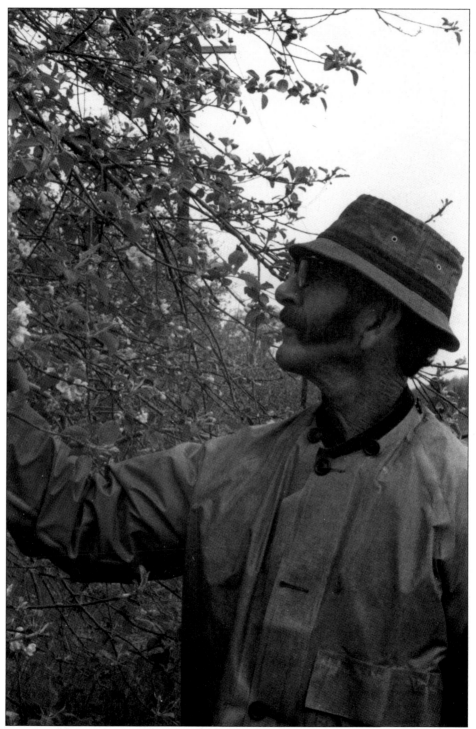

In this 1973 photograph, Fred Clark, owner of Clarkdale Apple Orchard, is picking some of his own apples. In 1946, he took over the orchard from his father. Now, his son Tom Clark runs the business. (Courtesy Betty Hollingsworth.)

Members of the Fuller family are shown on May 24, 1883, in front of their gambrel-roofed house, located in the Bars section of Deerfield. (Courtesy Richard Arms and Mary Marsh.)

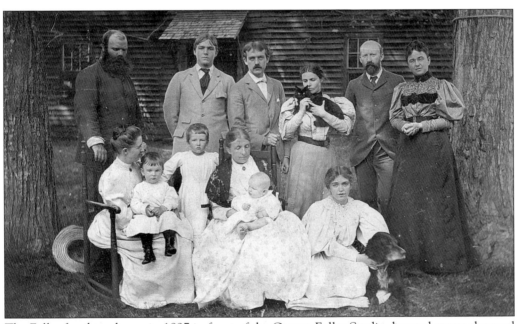

The Fuller family is shown in 1897 in front of the George Fuller Studio, located across the road from the Fuller home. From left to right are the following: (front row) Mary (holding George), Katherine, Agnes (holding Clara), and Violet Fuller; (back row) George Spencer, Arthur, Henry, Lucia, Robert, and Bessie Fuller. This was a very artistic family. (Courtesy Richard Arms and Mary Marsh; photographers Frances and Mary Allen.)

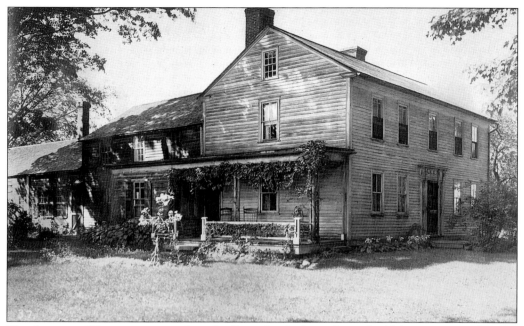

This house in Wapping remained in the Root family from the early 18th century until it was purchased by Robert and Nancy Bell in 1956. The back section was built *c.* 1740, and the front was added *c.* 1790. An attached rear shed, the first Deerfield schoolhouse, was removed to Historic Deerfield and become the Wapping schoolhouse. (Courtesy Peter S. Miller.)

This September 1889 photograph is titled "Mr. Asa Root's Barn—Wapping—Deerfield." It was taken by famous Deerfield painter James Wells Champney. (Courtesy Al Dray.)

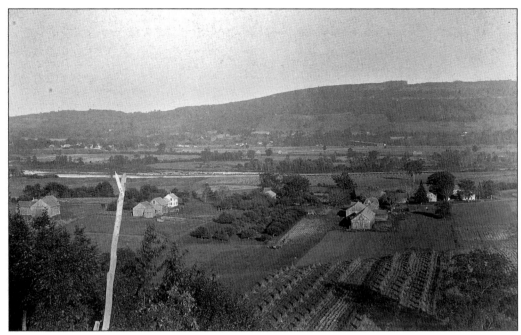

The Deerfield Valley is pictured c. 1890 from Upper Road in West Deerfield. (Courtesy the Historic Society of Greenfield; photographer Cyrus M. Moody.)

In 1910, the Union Church was organized and met in the former Baptist church in Wisdom, very near the Lower Wisdom Cemetery. This photograph, taken in 1908 shows the interior view of that church. The church was taken down c. 1947. (Courtesy Peter S. Miller.)

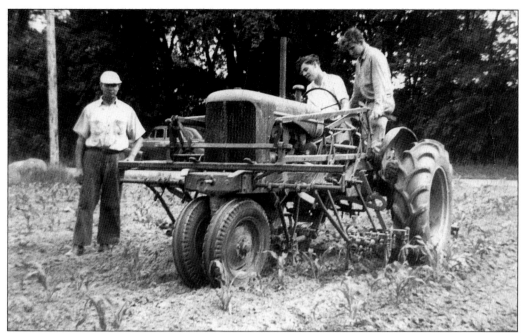

David Nobel, an exchange student from Wales, sits on a tractor on the Smiaroski Farm in Mill Village. Behind him is Richard Smiaroski, and standing on the left is Richard's father, Anthony Smiaroski. This photograph was taken in the early 1950s. (Courtesy Richard and Nansi Smiaroski.)

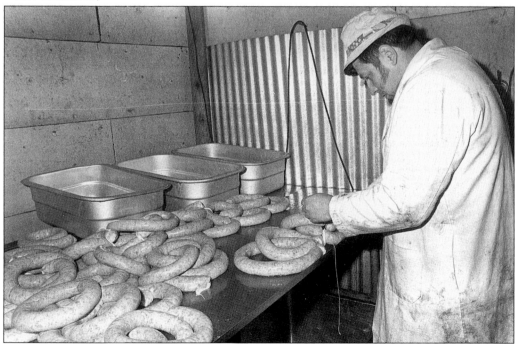

John Pekarski is shown here doing preparation work for smoking Polish sausages. The Pekarski Sausage Company is located on the Conway Road. The business was started by T. Walter Pekarski as a custom slaughterhouse in 1948. (Courtesy John Pekarski.)

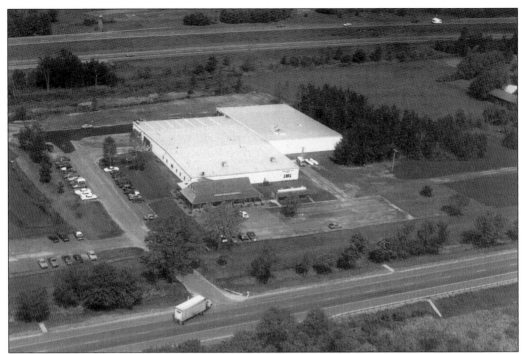

This 1985 aerial view shows the original Yankee Candle Company retail store and factory, built in 1983. In 1985, an addition (right) was built. Over the years, many additions and changes have been made to the complex. It is one of the most visited places in Massachusetts. (Courtesy Michael Kittredge.)

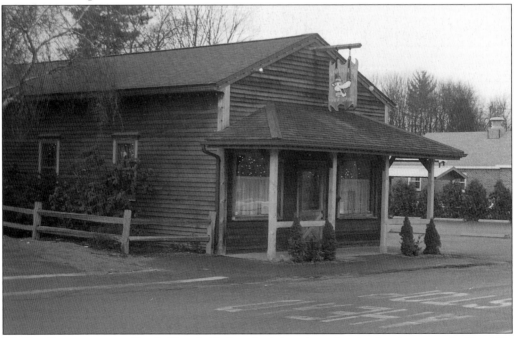

Wolfies Restaurant, in South Deerfield, is a favorite place for the locals to eat in Franklin County. (Photographer Peter S. Miller.)

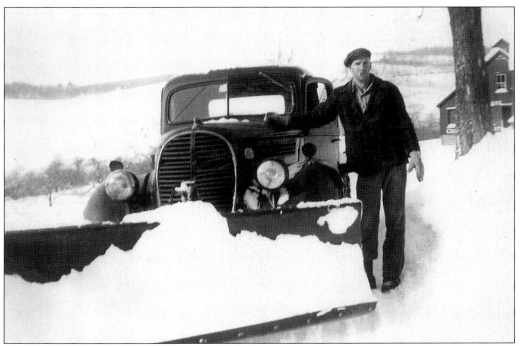

In the early 1940s, this man was the manager of Clarkdale Orchards. He lived in the farmhouse on the property. (Courtesy Fred Clark.)

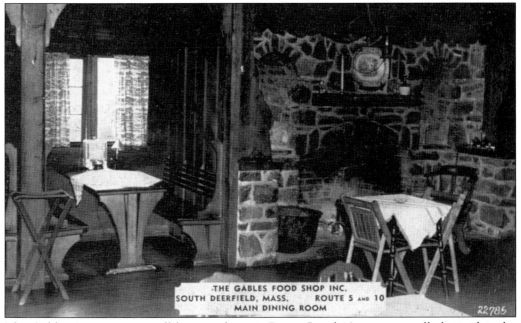

THE GABLES FOOD SHOP INC.
SOUTH DEERFIELD, MASS. ROUTE 5 AND 10
MAIN DINING ROOM 22785

The Gables Restaurant, a well-known place on Route 5 and 10, was originally located at the site of the Lighthouse gas station. The lighthouse is still there. Much later the restaurant business was moved across the road. (Courtesy Helen Petrovich.)

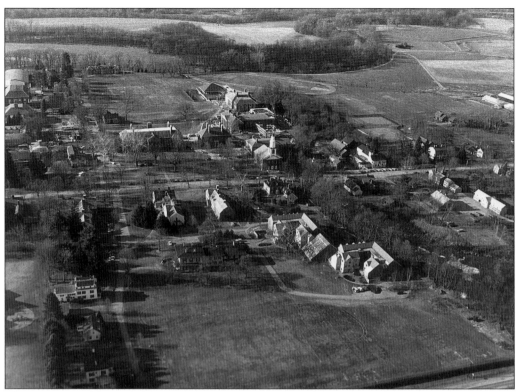

The center of Old Deerfield is seen from the air on December 7, 1988. (Courtesy the Recorder.)

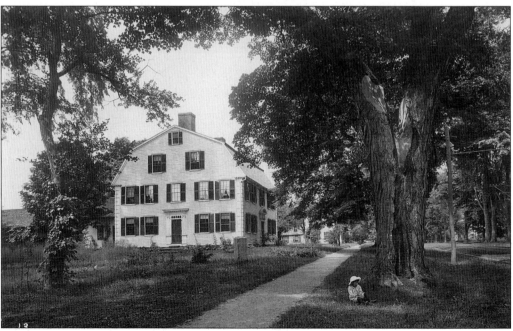

After the Revolutionary War, Joseph Stebbins built this house in Old Deerfield. Note the child by the tree. (Courtesy Peter S. Miller.)

Five

A Collection of Deerfield Photographs

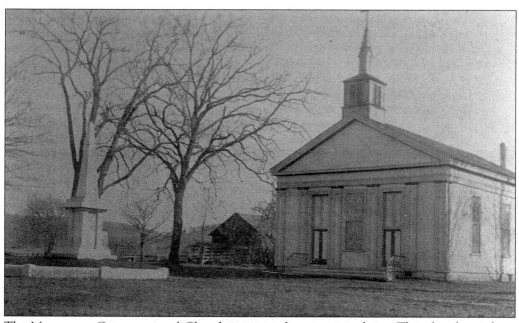

The Monument Congregational Church is pictured at its original site. This church was later moved south down Main Street. The church was sold and became St. James Church. Due to the moving of the Old Congregational Church down the street, some church members split off from membership of that church and founded this church. (Courtesy Betty Hollingsworth.)

This *c.* 1867 photograph by Pelham Bradford of Greenfield shows the front of the Frary House and the Pocumtuck House in Old Deerfield. (Photographer Pelham Bradford.)

During the 1860s, Main Street in Old Deerfield was lined with tall elm trees. On the left is the Pocumtuck House, and on the right is the common. Note the horse in the distant right side of the road. This may have been a photographer's wagon. (Courtesy Peter S. Miller.)

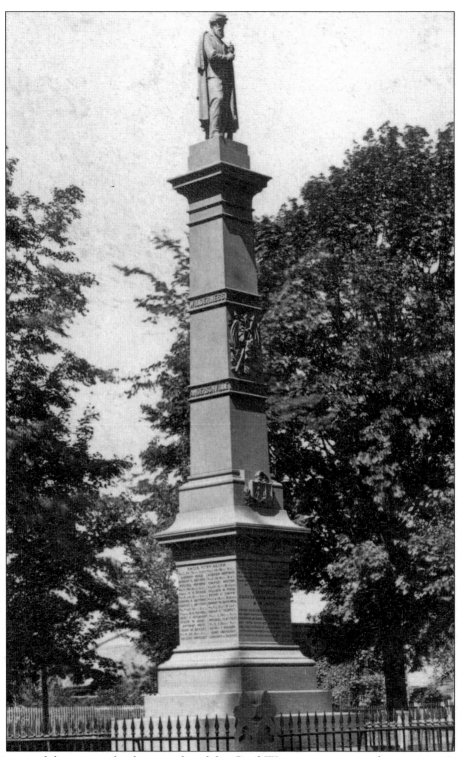

This is one of the very early photographs of the Civil War monument on the common in Old Deerfield. (Courtesy Peter S. Miller; photographers Egbert Horton and Henry Wise.)

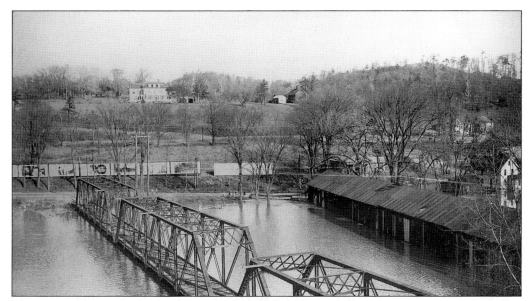

The Deerfield River is shown during the 1927 flood. The rails have been torn up off the trolley bridge. The water line was up to the bottom of the covered bridge. On Cheapside Street, there were a lot of billboards. (Courtesy Peter S. Miller.)

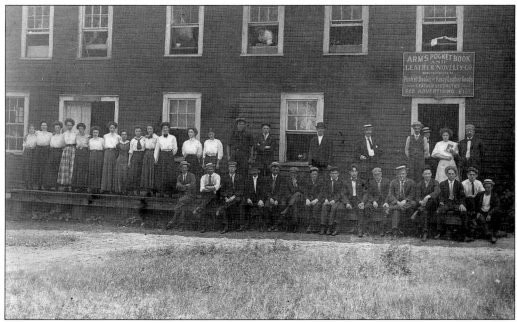

On the back of this postcard is written "The Arms Mfg. of paperback books." This must be the work force at the Arms Pocketbook Factory in South Deerfield. (Courtesy Peter S. Miller.)

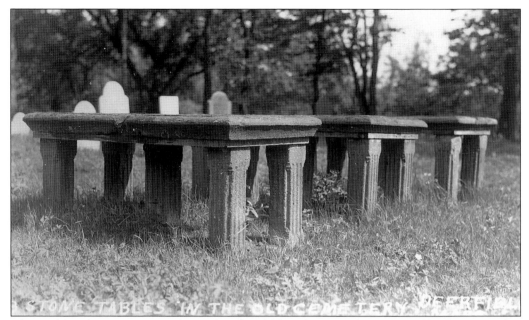

These tabletop gravestones are located in the old burial yard at the end of Old Albany Road in Old Deerfield. (Courtesy Peter S. Miller; photographer Ned Lamb.)

This is one of the YMCA buildings that once stood in the East Deerfield Freight Yard. (Courtesy Peter S. Miller.)

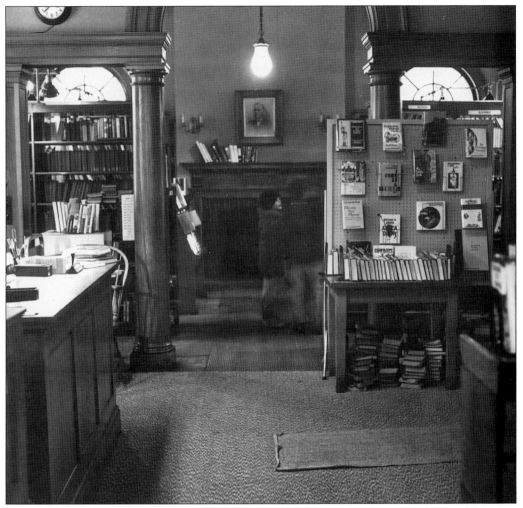

The inside of the Tilton Library in South Deerfield is pictured in the 1970s. (Courtesy Betty Hollingsworth.)

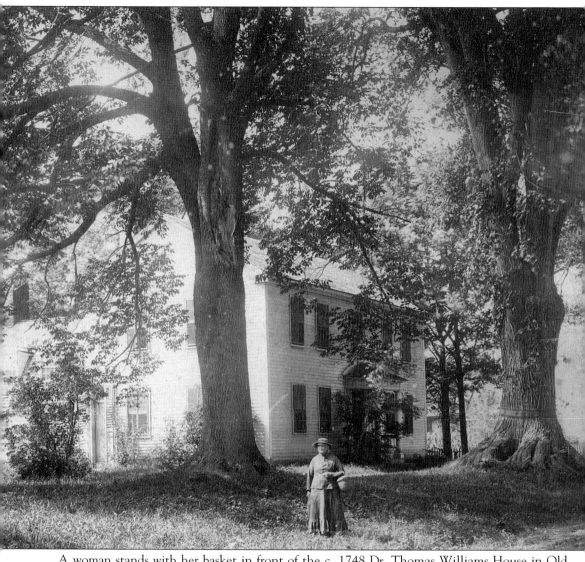

A woman stands with her basket in front of the *c.* 1748 Dr. Thomas Williams House in Old Deerfield. (Courtesy Richard Arms and Mary Marsh.)